STREETS OF AFGHANISTAN

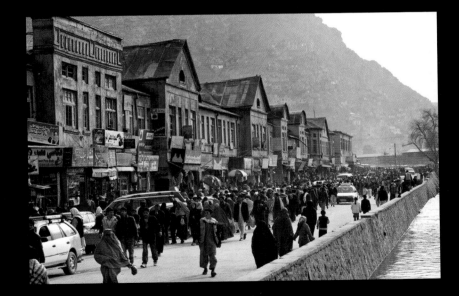

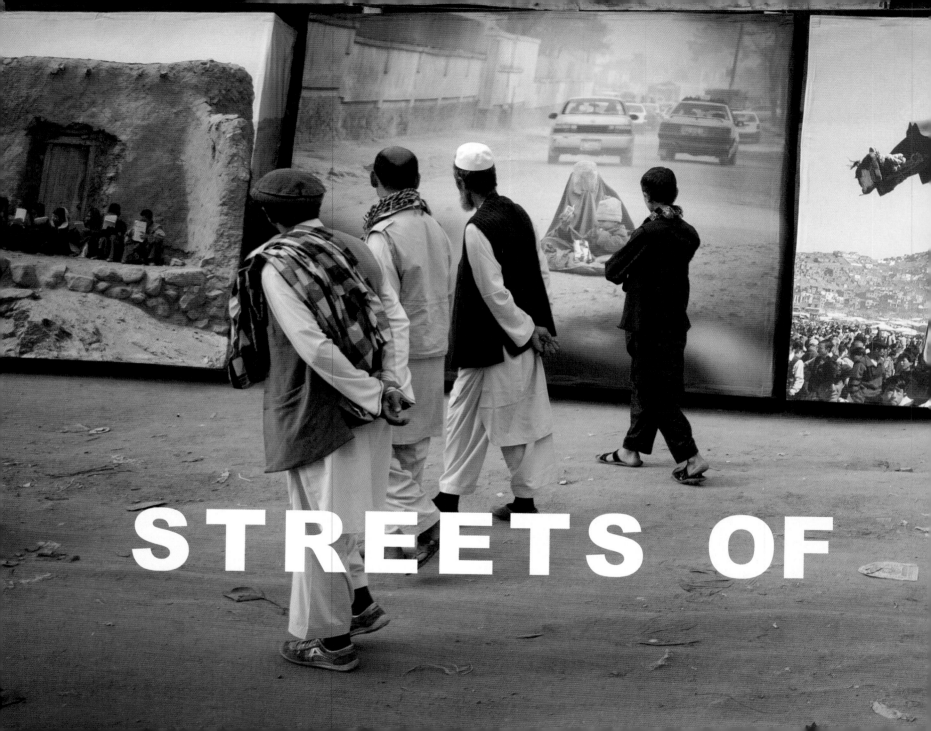

STREETS OF

AFGHANISTAN

BRIDGING CULTURES THROUGH ART

BY SHANNON GALPIN AND LIBERO DI ZINNO

hatherleigh
Improve your life. Change your world.

Hatherleigh Press is committed to preserving and protecting the natural resources of the earth. Environmentally responsible and sustainable practices are embraced within the company's mission statement.

Visit us at www.hatherleighpress.com and register online for free offers, discounts, special events, and more.

Streets of Afghanistan

Library of Congress Cataloging-in-Publication Data is available upon request.
ISBN: 978-1-57826-467-4

Cover and Interior Design by Dede Cummings and Carolyn Kasper, DCDESIGN

Printed in the United States

10 9 8 7 6 5 4 3 2 1

"Vision without action is merely a dream. Action without vision just passes the time. Vision with action can change the world."

— Joel A. Barker

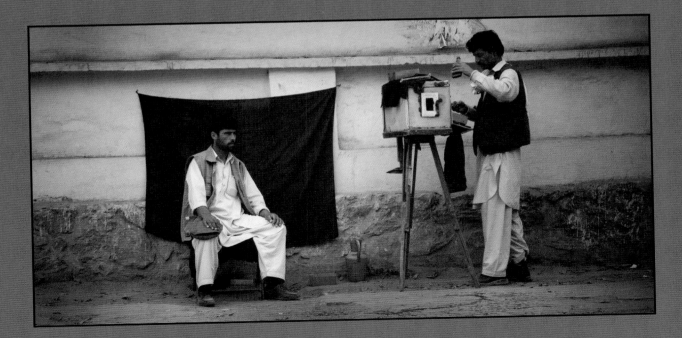

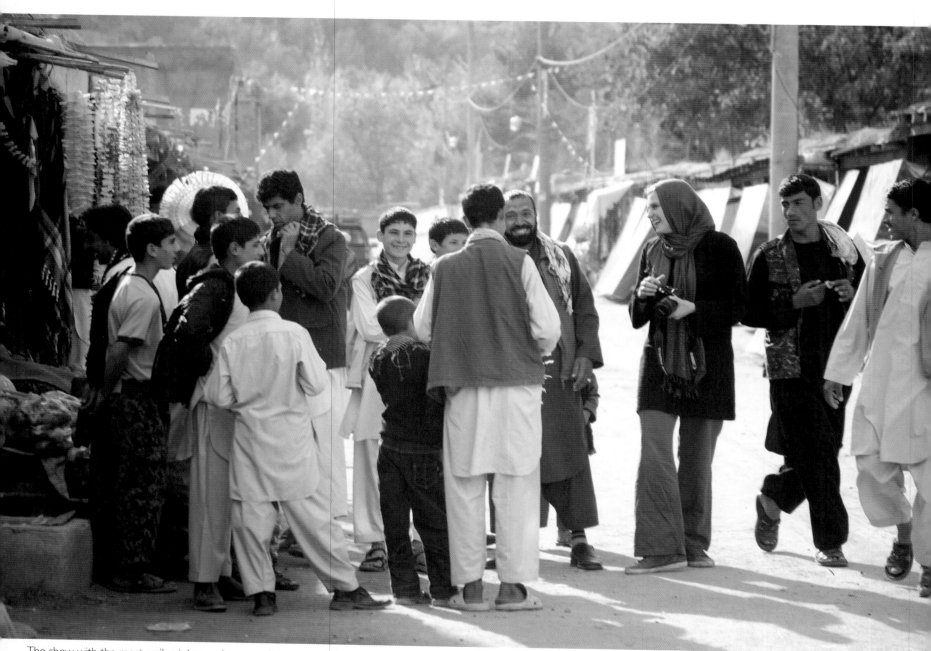

The show with the most smiles, jokes, and community engagement was in the village of Istalif.

Contents

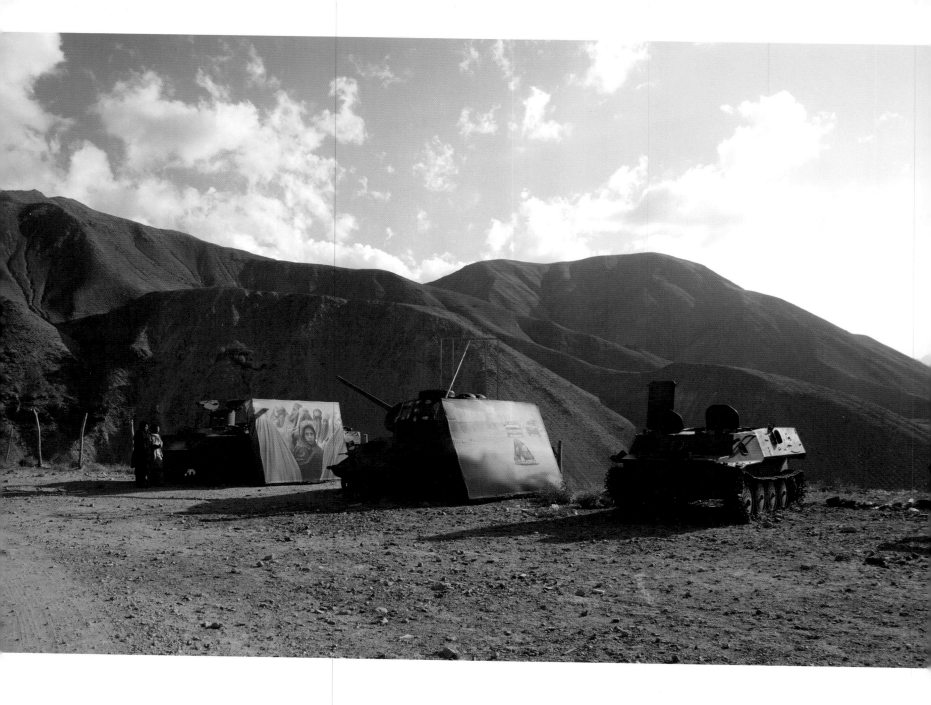

Introduction

IN 2008, NEARING FOUR DECADES of ongoing conflict, Afghanistan was still front and center in the news and media. The U.S. military had been embroiled in Afghanistan for seven years following the September 11th attacks. Security had peaked the year before, and was showing signs of faltering.

Despite progress for women's rights, education, infrastructure, and a decrease in overall violence since the Taliban had been pushed out, few private citizens or tourists traveled in Afghanistan. Much of the country was viewed from the lens of the 24-hour news cycle and media, which focused on the ongoing conflict surrounding the U.S. military and the role of international forces to help stabilize the country, fight the Taliban, and train Afghan security forces. This meant that the typical story was of violence, terrorism, poverty, and oppression. Much of the media attention was focused either in the southern or eastern provinces, mostly footage of desert and stark landscapes or from the capital city of Kabul. Daily stories of suicide bombers and acid attacks set the tone that this was a country "off-limits" and without hope.

Yet digging deeper, one could find stories of tourists flocking to Afghanistan, following the Hippie Trail, of Peace Corps workers placed in Kabul, riding their bikes to work each day, and of a modern

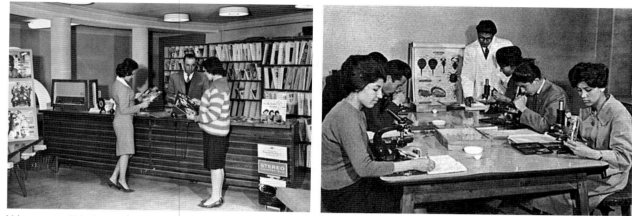

Women at a Kabul record store in the 1960s. *Courtesy of Cal State East Bay President Mohammad Qayoumi and the Information Ministry of Afghanistan.*

Men and women studied alongside each other at a biology class at Kabul University. *Courtesy of Cal State East Bay President Mohammad Qayoumi and the Information Ministry of Afghanistan.*

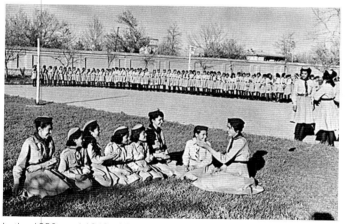

In the 1950s and 1960s, Afghanistan had Boy Scouts and Girl Scouts. These programs, and many more like them, disappeared after the Soviet invasions in the 1970s. *Courtesy of Cal State East Bay President Mohammad Qayoumi and the Information Ministry of Afghanistan.an.*

moving Islamic country steeped in culture, history, and the romance of the Silk Road. Irish woman, Dervla Murphy, rode through this country on her bike with nothing more than a shotgun for wolves and the belief in the traditions of Muslim hospitality towards travelers, chronicled in *Full Tilt*. Old black and white photographs of Kabul in the 1960s showed modern Afghan women in stylish pencil skirts with bare legs and high heels, short hair and no headscarves, shopping at record stores, going to university alongside men, and shopping for clothes.

Time and time again, I would hear people discussing Afghanistan as a hopeless country. A fourth century abyss of poverty and terrorism. A country not worth saving, much less losing American lives over. News organizations tallied the death toll of American lives lost, but never did I hear mention of how many Afghan lives were lost. As though the media, and the country, had forgotten that this was a country we were there to liberate, not occupy, that Afghan citizens suffered under the Taliban and the endless conflicts, including the current one.

The Afghanistan I have been fortunate enough to explore is much more complicated, colorful, and intriguing. It's a country that has endured much and that steadfastly moves forward. The youth movement has sparked a burgeoning art scene in Kabul and beyond. Young technology and social entrepreneurs are working to spark innovation and keep the educated youth in Afghanistan to work for its future. The first national park, Band-e Amir, opened and is actively courting Afghan and international tourists alike. Sports are flourishing; even women are publicly taking part in sports and activities previously unheard of. I've always believed that, beyond humanitarian and aid work which targets survival, art and sport play an important role in rebuilding communities and inspiring hope.

—*Shannon Galpin*

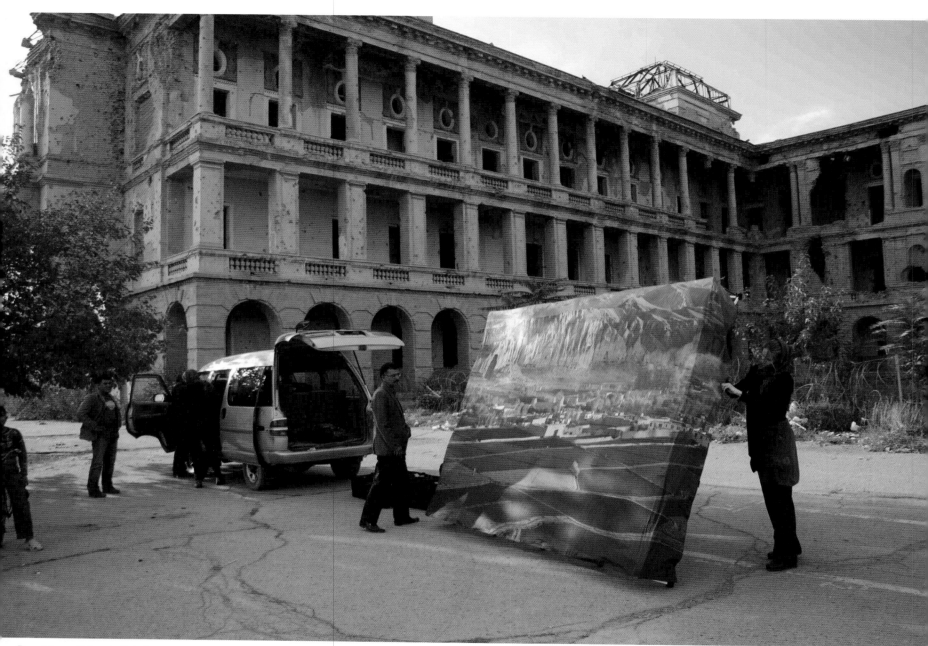

Darul Aman Palace in Kabul.

The Genesis

In 2006, I created Mountain2Mountain, a non-profit dedicated to empowering the voice and value of women and girls in conflict zones. In 2007 and early 2008, I partnered with two organizations to support projects and raise funds while I navigated the legalese of achieving non-profit status. I knew I wanted to do more than raise money and implement projects. I knew that I wanted to connect communities and cultures. That if people could connect with the people and the stories in the places we were working, we could rally support. It started with a speaker event with a non-profit that worked in Central Asia. I reached out to several photographers that had worked in the same areas and asked them to donate prints to set a backdrop to the event. The success of that event made me realize how much I loved photography as a medium to story-tell. The visceral impact it could create emotionally, and the depth of space and time reflected in a single image, could connect people in ways words cannot.

For a partnership with a non-profit working in Nepal, I reached out to the world's most beloved Himalayan photographers—Galen Rowell, Jimmy Chin, Beth Wald, Phil Borges, Nevada Weir, and Libero

Di Zinno—to create a photography exhibition that could rally support for the projects while connecting the viewers to the people and region. While the exhibition was beautiful, even with getting four images by the late Galen Rowell donated from his archives, the attempt to rally support fell short.

Undeterred, I considered how people interacted with art exhibitions, what made them purchase a piece, and what made them connect to the project it represented as a whole.

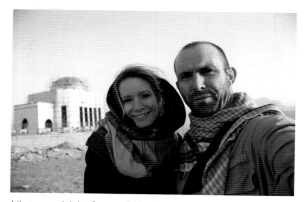

Libero and I in front of King Nadir Shah's Mausoleum in Kabul, Afghanistan, 2008.

Those questions were in my mind when I decided to travel to Afghanistan in 2008. Mountain2Mountain was ready to develop its own programs, and I chose Afghanistan. Afghanistan was repeatedly ranked the worst place in the world to be a woman—few women traveled there outside of the military, embassies, or NGOs that required security—and it was a region of the world few believed had a future worth saving. Rather than putting me off, the challenges that Afghanistan embodied excited me, made me feel that there was a real opportunity to create a bridge between our cultures that could foster greater understanding of our common humanity and rally support for our future projects.

Friend and photographer, Libero Di Zinno, came along to document the trip in November 2008. Our first meeting in Kabul was with AINA Photography Agency.

MEETING THE PHOTOGRAPHERS

We had our first meeting in Kabul at the offices of AINA Photo and *Kabul Weekly*. Faheem Dashty welcomed us to Kabul and discussed the history of AINA Photo and the talents of the burgeoning Afghan photojournalists trained by AINA.

The esteemed Faheem Dashty. Secretary to Northern Alliance Commander, Ahmad Shah Massoud; editor-in-chief for *Kabul Weekly*; and vice president of AINA Photo.

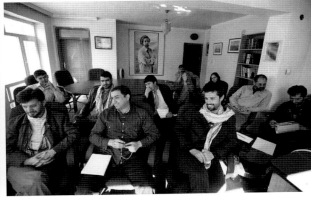

The men and women of AINA Photo, including Kabul-based Australian photojournalist and filmmaker, Travis Beard (far right, front row), who became a lifelong friend and advisor after that initial meeting.

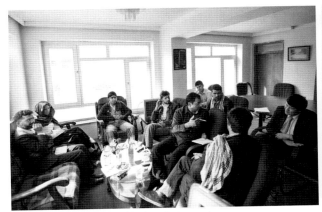

Discussing the project with the photographers.

Speaking after the meeting with Faheem Dashty and AINA photographer, Ali Omid.

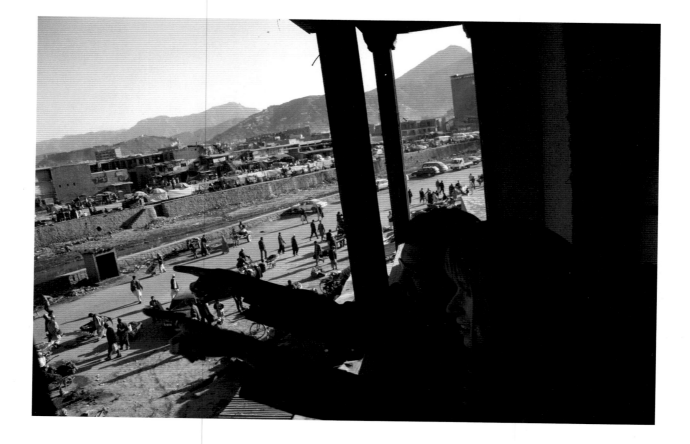

Upon my return to the United States, I had the support of AINA, images from the Afghan photographers, and the inspiration to create a larger than life photo exhibition that would challenge perceptions of Afghanistan and hopefully rally support for future Afghan projects.

Portrait by Paula Bronstein.
Photo credit: Krystal Garvin.

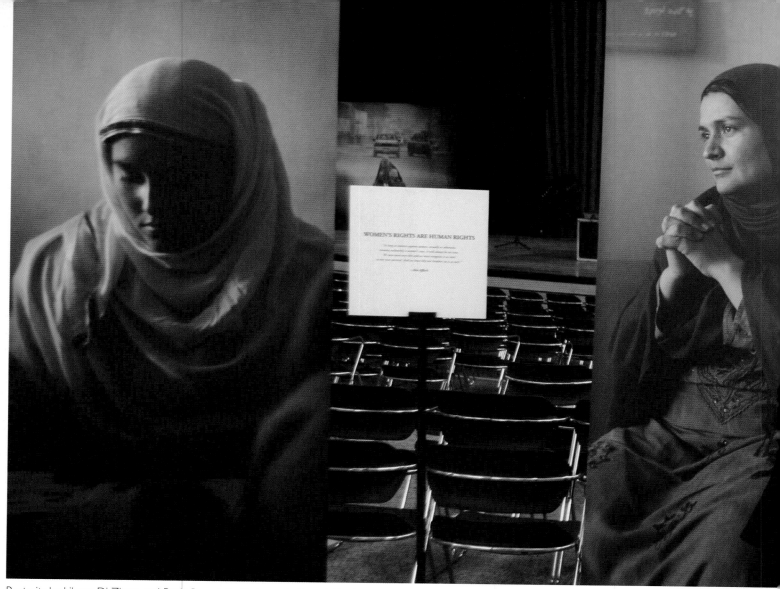

Portraits by Libero Di Zinno and Paula Bronstein. *Photo credit: Krystal Garvin.*

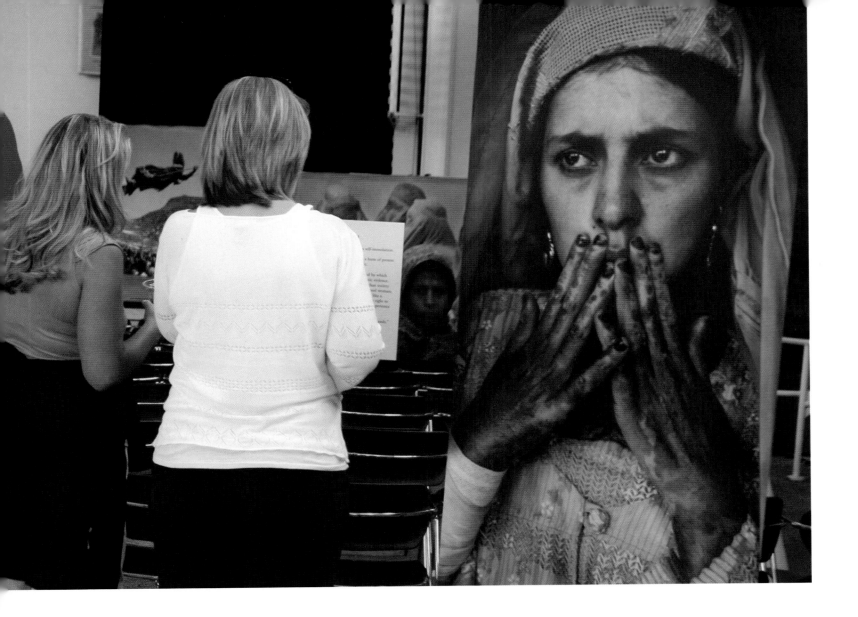

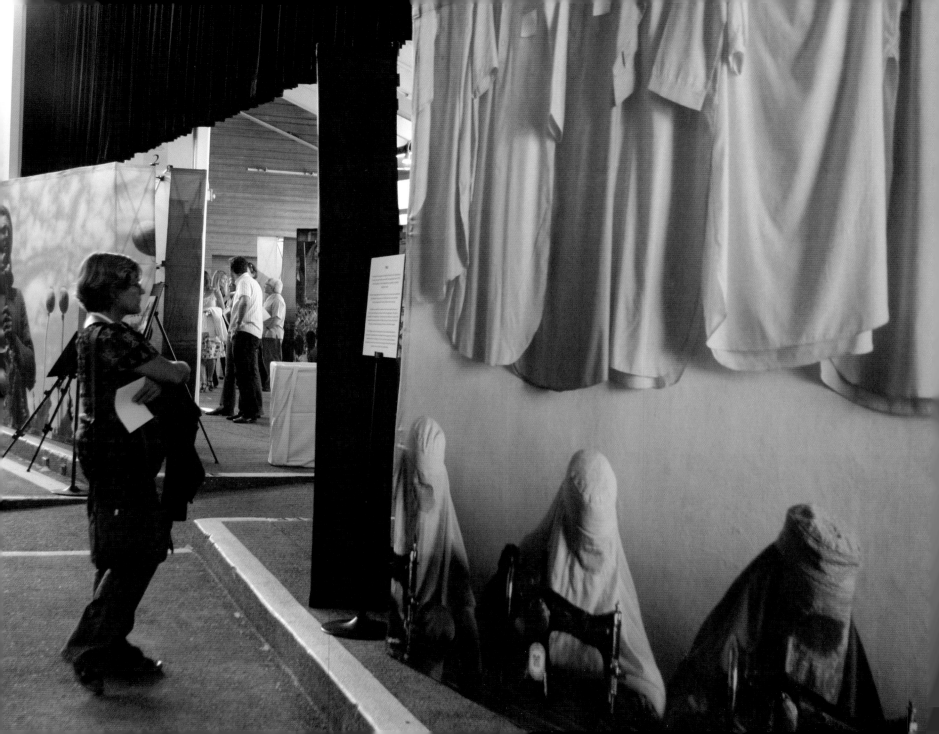

I reached out to Western photographers with unique experiences in Afghanistan to bring together a variety of perspectives and bridge culture and community through the shared passion of capturing beauty and storytelling through the lens.

Beth Wald, Paula Bronstein, Travis Beard, Ann Curry, and the late Paula Lerner joined Libero Di Zinno and the Afghan photographers, all members of AINA Photo at the time, Gulbidden, Najibullah Musafer, Wakil Kohsar, and Mariam Alimi.

After two and a half years of struggling to figure out logistics, funding, and support, the first exhibition opened at the Denver Art Museum for a one-night exhibition and fundraiser in April 2011, followed by a show in Breckenridge, Colorado.

The U.S. exhibitions were set up with storyboards that explained the ongoing struggle for women's rights, the progress in girls' education, the spirit of sports like football and cricket played at Kabul Stadium, the culture of the traditional horse sport of buzkashi, the stunning landscapes that could herald a future tourism trade, the progress Afghanistan has seen in the past decade, and the role of opium farming in Afghanistan's high heroin addiction and ongoing war with the Taliban.

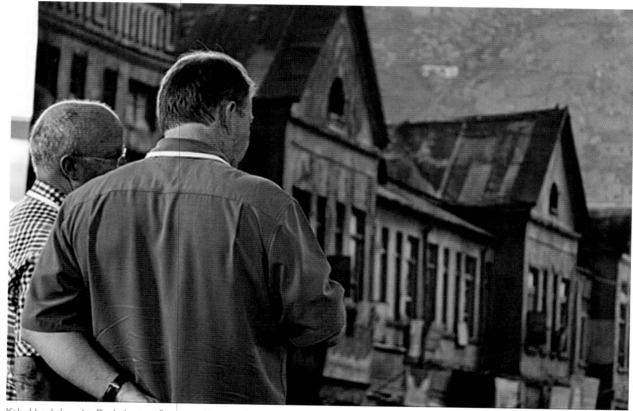

Kabul backdrop by Paula Lerner. *Photo credit: Krystal Garvin.*

We also created a series of black and white photography from Afghanistan in the 1960s and displayed them on easels to showcase Kabul as a progressive and peaceful city. This series showed that Afghanistan is much more than what Americans see in the news and media today, giving a sense of hope for what could be, based on what was.

Photo credit: Krystal Garvin.

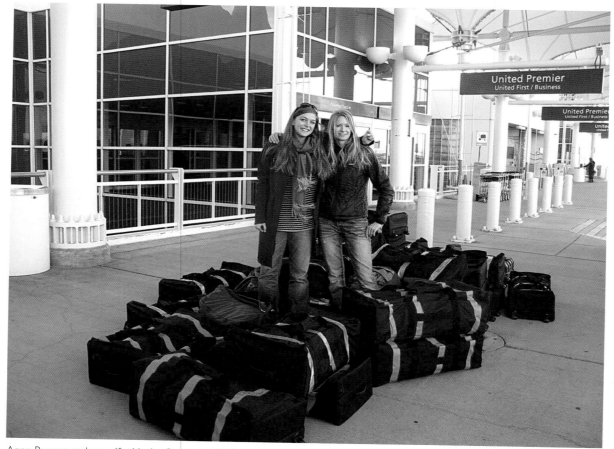

Anna Brones and myself with the Streets exhibition outside Denver International Airport.

Logistics

IN 2012, I MADE THE DECISION to bring the exhibition to Afghanistan. Knowing I couldn't do this solo, I enlisted the help of good friend and writer, Anna Brones, to join me. In the spirit of her "say yes to everything" policy, she gulped and said, "Hell, yes." I asked Libero if he wanted to come back to document the exhibition, which was met with a resounding and heartfelt, "Yes, please."

I had never traveled with a crew before, so this was my first experience in arranging logistics and working with a group to organize security, visas, customs/cultures, and even wardrobe solutions. Anna had never been to Afghanistan, or any warzone, so there was a lot of apprehension that went with the unknown, and Libero had only visited once, four years prior. Getting permission to film publicly—not to mention arranging lodging and transportation of the crew with 31 bags, photography equipment, and luggage—would be difficult anywhere, but in Afghanistan it was an even larger challenge when you factor in security and cultural customs around gender. My four years of experience, the advice of friends living in Kabul, plus the amazing talents of my dear friend and fixer, Najibullah, meant that we arrived ready to work and with everything in place.

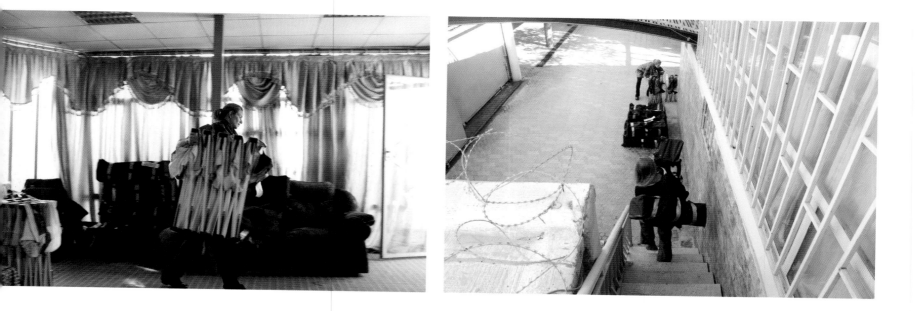

We departed Denver International Airport with the Streets of Afghanistan exhibition, thanks to the three-truck convoy that dropped us and our gear outside of United Airlines. Miraculously, all 31 bags arrived in Kabul after three flights, two delays, and 49 hours of travel. It took five porters to help maneuver our luggage through Kabul International Airport and one confrontation with the customs agents before we walked outside into the dusty air of Kabul. Najibullah was at the exterior gate to meet us with minivan and smile to welcome us back to Afghanistan.

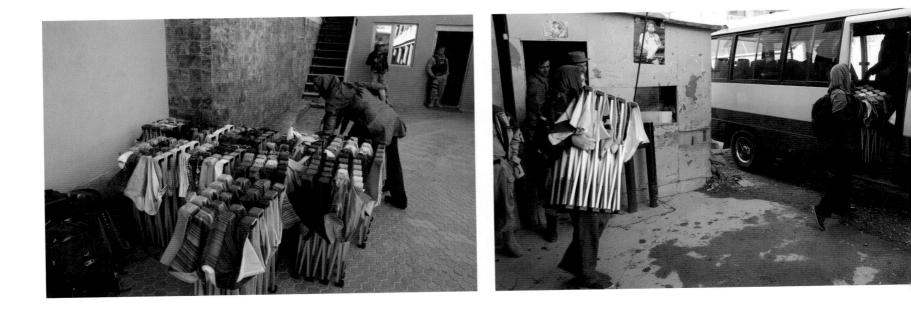

Once in our guesthouse in Kabul we were given an empty room as storage for the exhibition, but that meant carrying the heavy images, each an awkward 40 pounds, up and down narrow staircases, avoiding barbed wire, and loading them into the awaiting minibus.

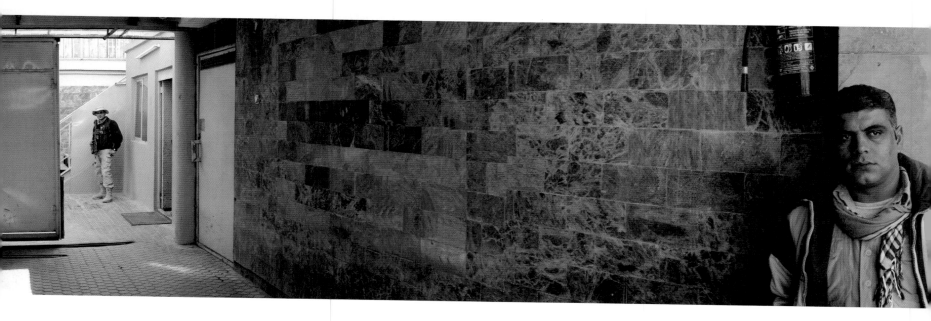

Streets of Afghanistan

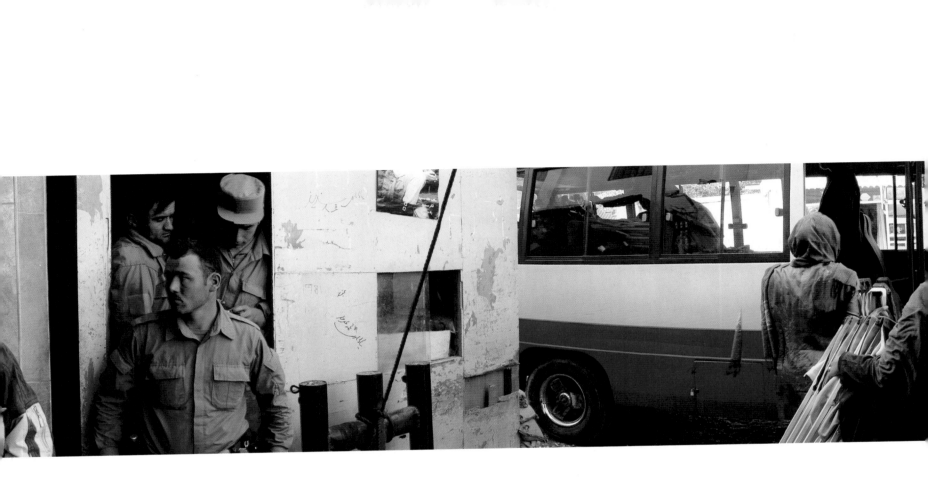

Streets of Afghanistan

Logistics

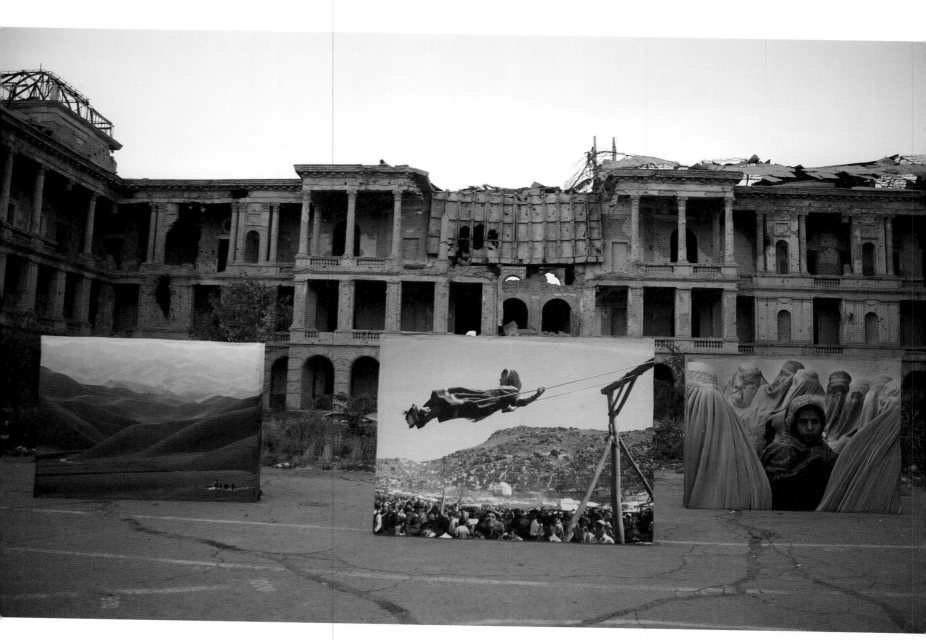

Streets of Afghanistan

Premiere Exhibition: Darul Aman Palace

THE FIRST SERIES OF PUBLIC ART EXHIBITIONS was a staging at the historic Darul Aman Palace in Kabul.

Darul Aman Palace was built in the early 1920s by King Amanullah Khan. It resides stoically on a small hillside 10 miles south of Kabul's city center. Decades of war have ravaged the palace. It has been set on fire twice, it has sustained heavy gunfire and shelling from rival Mujahideen forces that battled for control of Kabul. Today it is surrounded by barbed wire and guarded with a small group of Afghan National Army soldiers. The roof has caved in, the walls are riddled with bullet holes, piles of rubble line the interior walls, and Islamic graffiti is scattered throughout. Yet its presence and plans to reconstruct the palace as a historical gem of Kabul ensure that its current state is only a transition.

We set up the exhibition outside the palace to use the ruins as a backdrop for the images, and to allow passersby to interact with the art and speak with us.

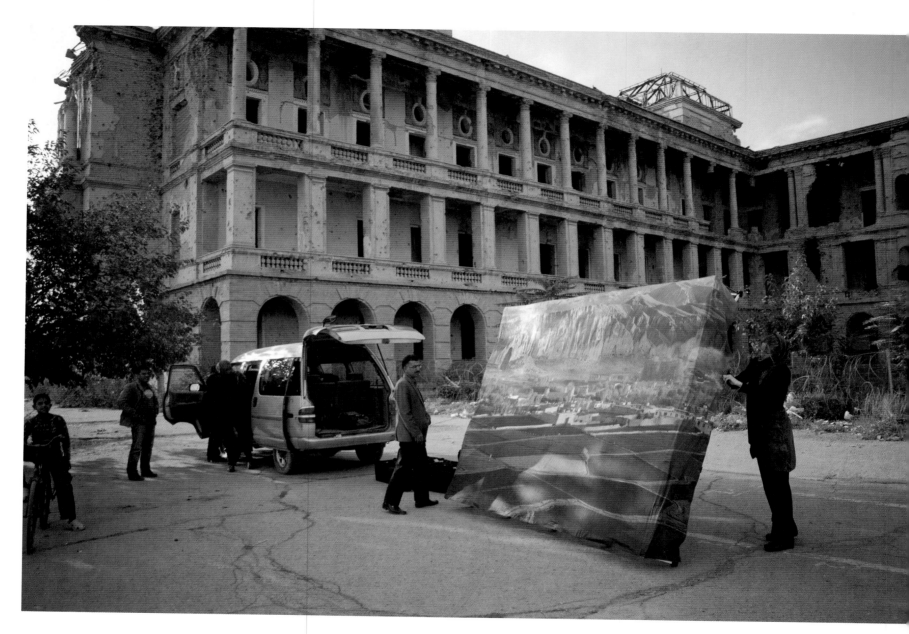

Streets of Afghanistan

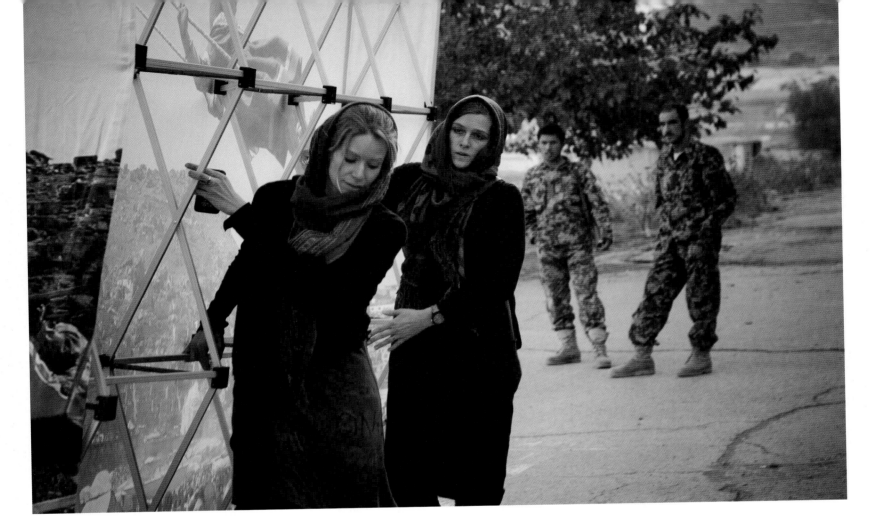

The Afghan guards watched curiously as we unloaded the minibus and started to unpack the largest of the images. Quickly, small crowds formed as we worked. As landscapes were set up, young boys got out their cameras and took photos of each other in front of the backdrop of Bamiyan and Badakhshan as though they were actually there.

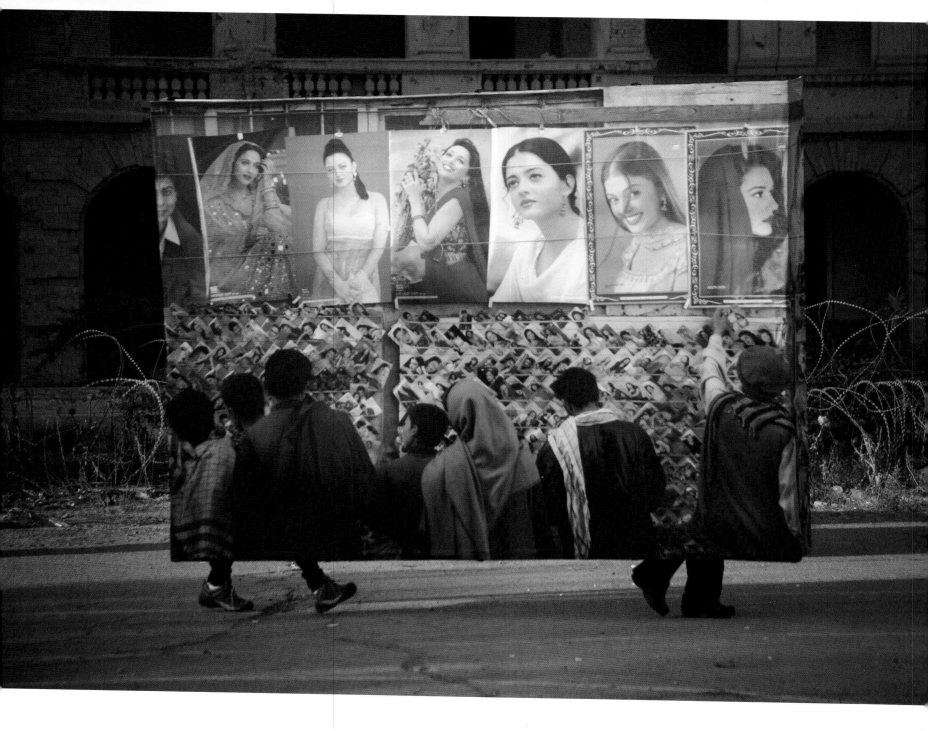

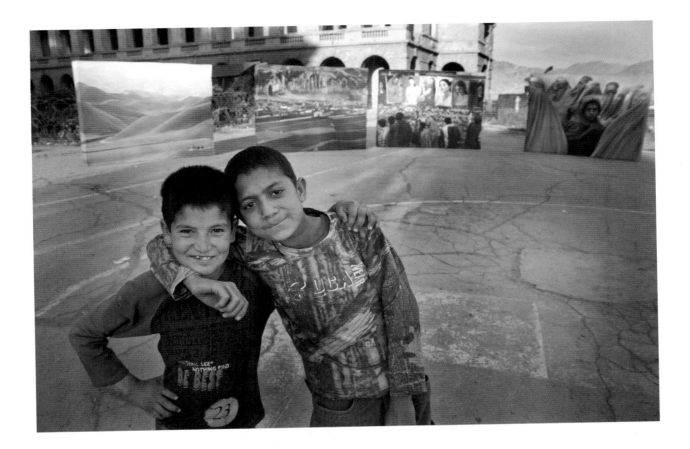

Premiere Exhibition: Darul Aman Palace

Anna and I speaking with locals that were walking by and had lots of questions.

As the sun set, the three images in front of the Darul Aman Palace, I took a breath and realized the exhilaration that was coursing through me at the realization that we had pulled off our first public exhibition in Afghanistan. I experienced the first real taste of the ephemeral nature of street art installations, the impermanence. We would set these images up and take them down again six more times during this trip, and each time I found myself disappointed at how empty the space felt without the images.

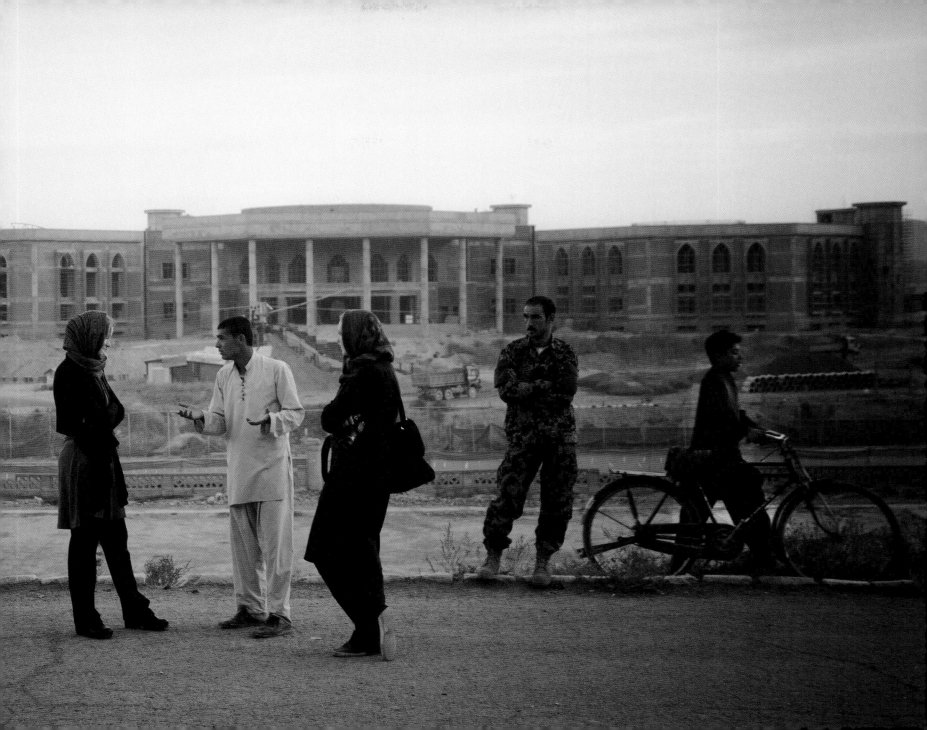

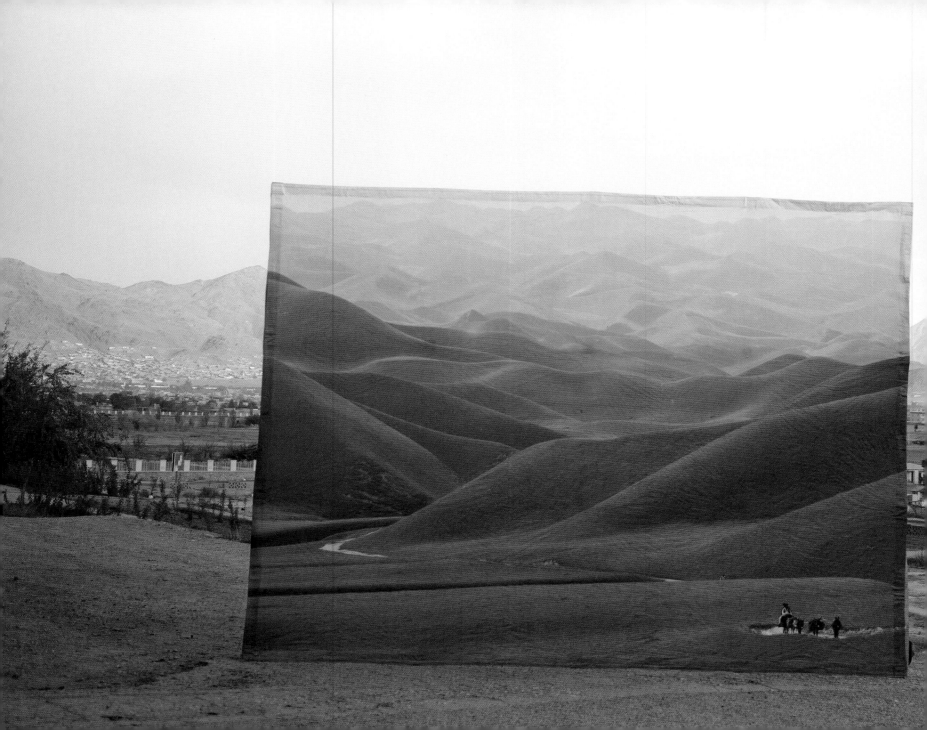

Setting up the photo that Beth Wald took many years ago in the province of Badakhshan in the northern most part of Afghanistan, we were astonished to find that it fit perfectly into the backdrop of Kabul's mountain range, as though it always belonged there.

33

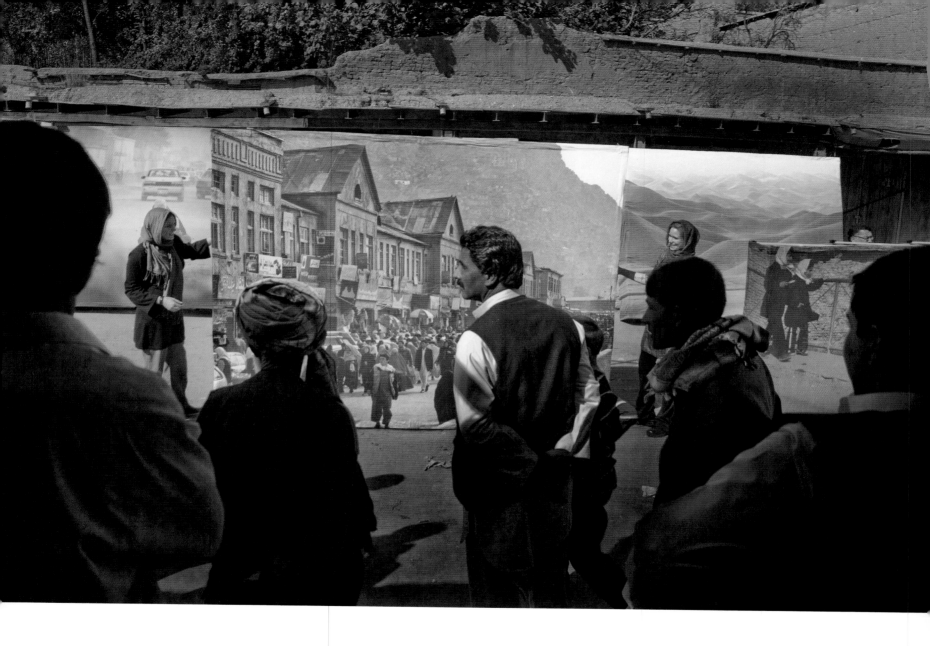

Streets of Afghanistan

Kabul

ISTALIF

The first village exhibition was in the village of Istalif on the first day of the three-day Eid celebration. Istalif is a small village northwest of Kabul, and is famous for its handmade turquoise glazed potteries.

We left Kabul early after loading the bus, to make the drive north of Kabul into the Shomali Plain. We arrived in time to set up while the majority of the village was in the small blue-and-white tiled mosque for morning prayers. There was one long street that led out of the mosque, lined with market stalls, which is where we planned to set up the exhibition along the length of the village.

Najibullah helped unload the exhibition, and after introductions with the local police, explained to the gathering crowd what we were doing. They curiously watched us unload the minibus and start to unfold the images in the dusty street.

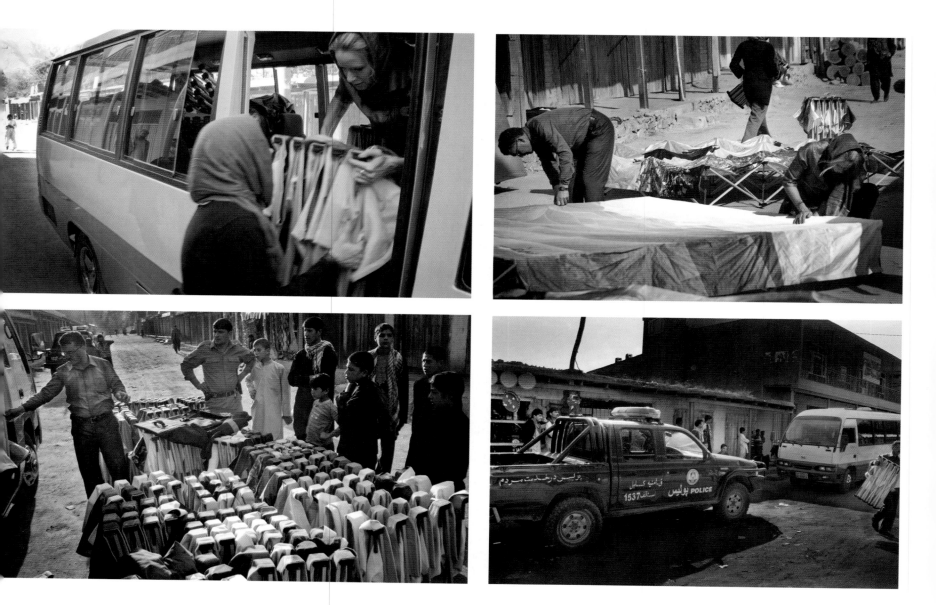

Streets of Afghanistan

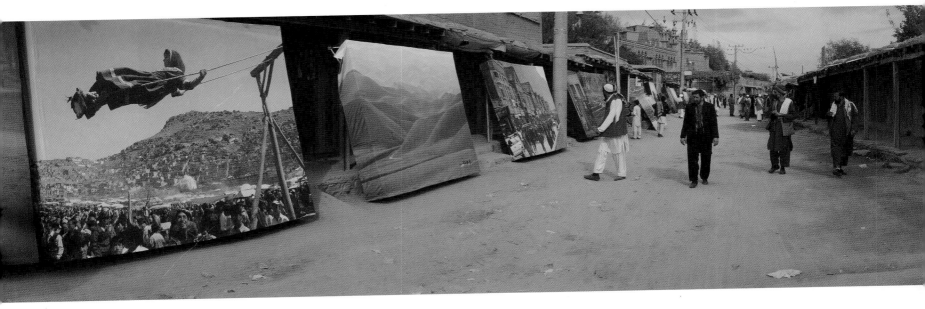

Kabul

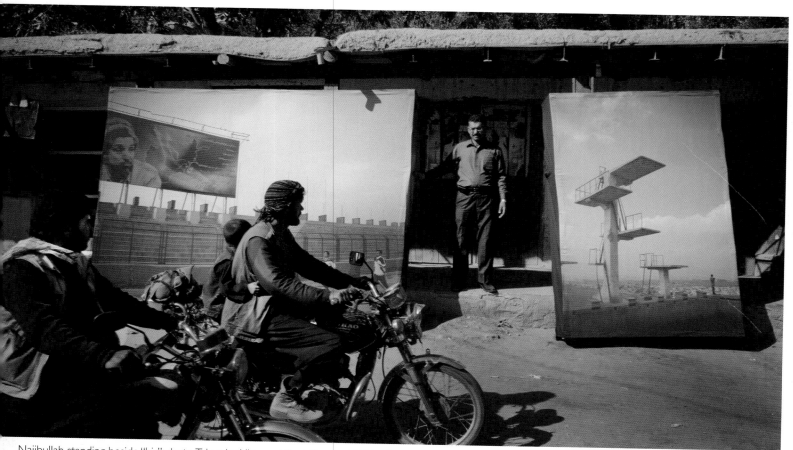

Najibullah standing beside "his" photo. Taken by Libero at the infamous hillside diving pool in Kabul on the last day of our visit together in 2008, Najibullah was standing on the corner of the pool videotaping the city spread out below us.

Streets of Afghanistan

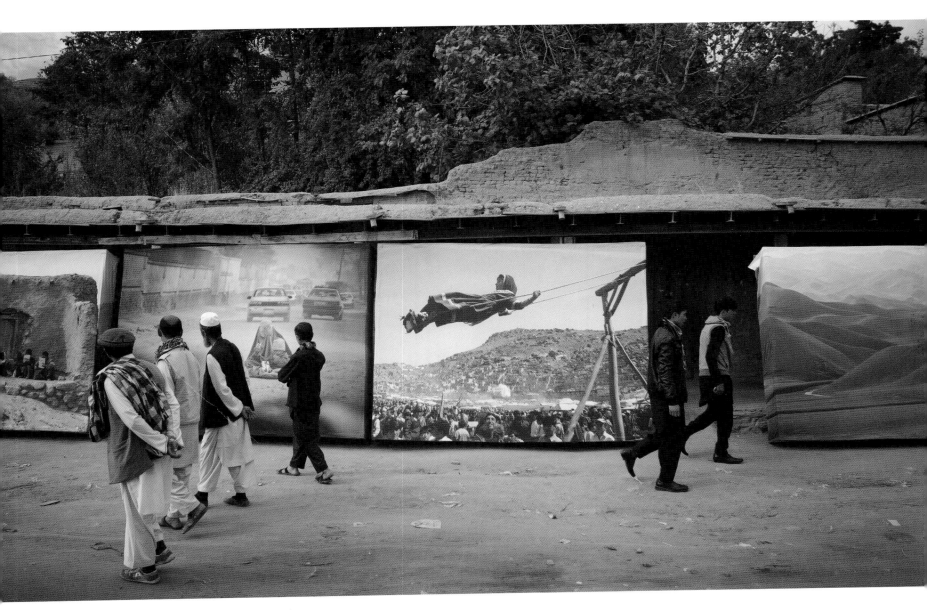

Kabul

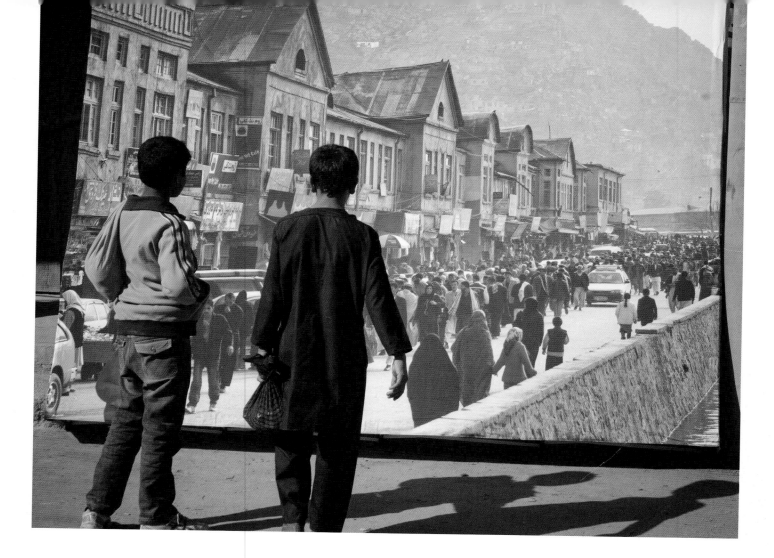

Most amazing was watching the young kids interacting with the images, standing for 10 minutes or more in front of the photo of Kabul, pointing out individual people and buildings while discussing the photo with each other.

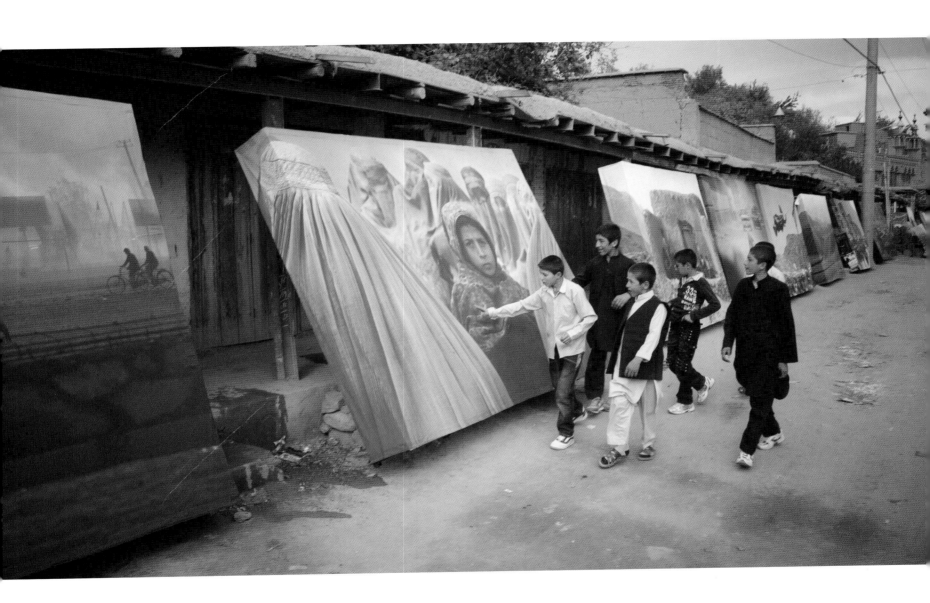

Kabul

It was a joy to see the young girls smiling shyly and touching the images as they walked by.

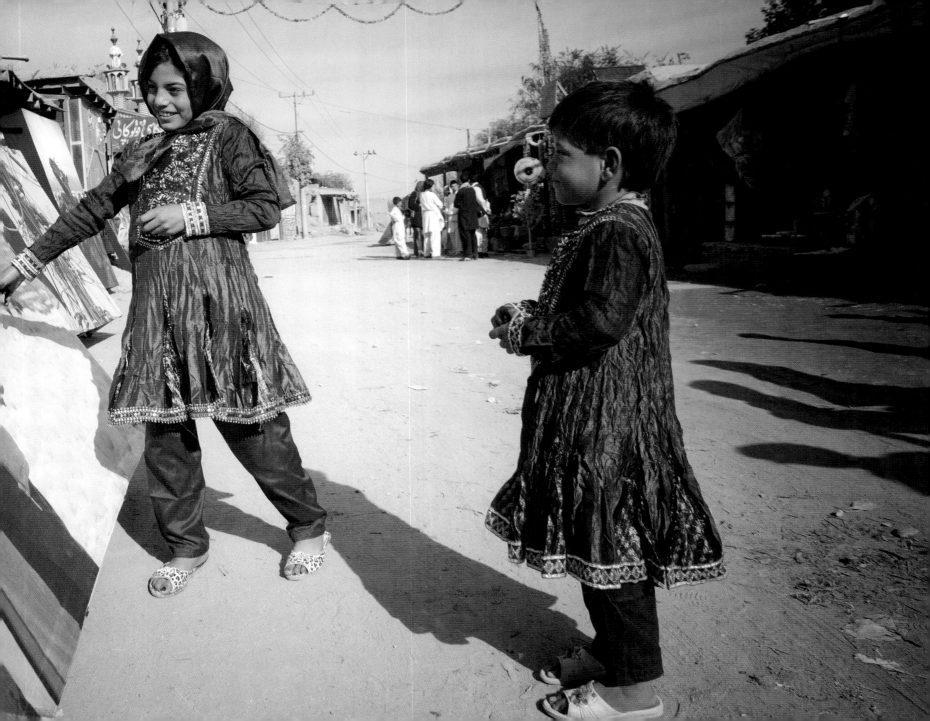

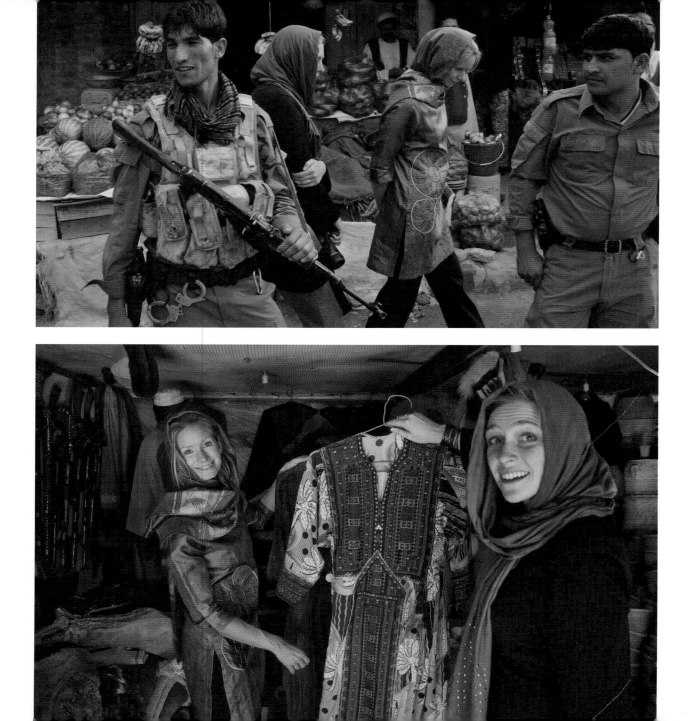

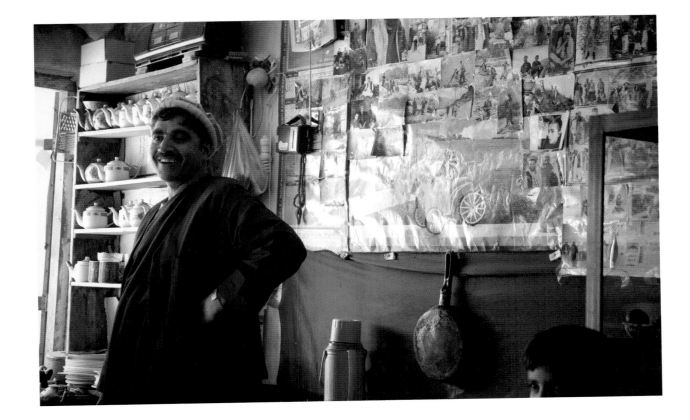

Anna and I took some time and walked throughout the village, talking with locals and popping into market stalls.

One of the shops we stopped in was a small teahouse where we later ate lunch. The owner was a large friendly man and behind him there were postcards and photos across the wall of famous Afghans like Massoud, and Afghan landmarks like the blue mosque of Mazar-i-Sharif. They were given to him as gifts, torn out of magazines, or purchased at postcard stands in Kabul. This is one of the most common ways that rural Afghans see photography as there are no magazines or galleries.

After walking through the length of the village, watching villagers viewing and interacting with the art, the offer of a bike ride was made. This was no ordinary bike; this was a bike with pinwheels, multiple horns, a flower vase, and fur wrapped around the front tied with a pink satin bow. This was an opportunity of a lifetime.

In a country where women don't ride bikes, this was more of a challenge to the foreigners and a unique way to interact with the locals.

After I took the bedazzled bike for a ride, Anna had a spin. While she was riding, one of the villagers spoke to me in English in awe, "It takes a lot of intelligence to ride a bike, I've never seen a woman do it."

Streets of Afghanistan

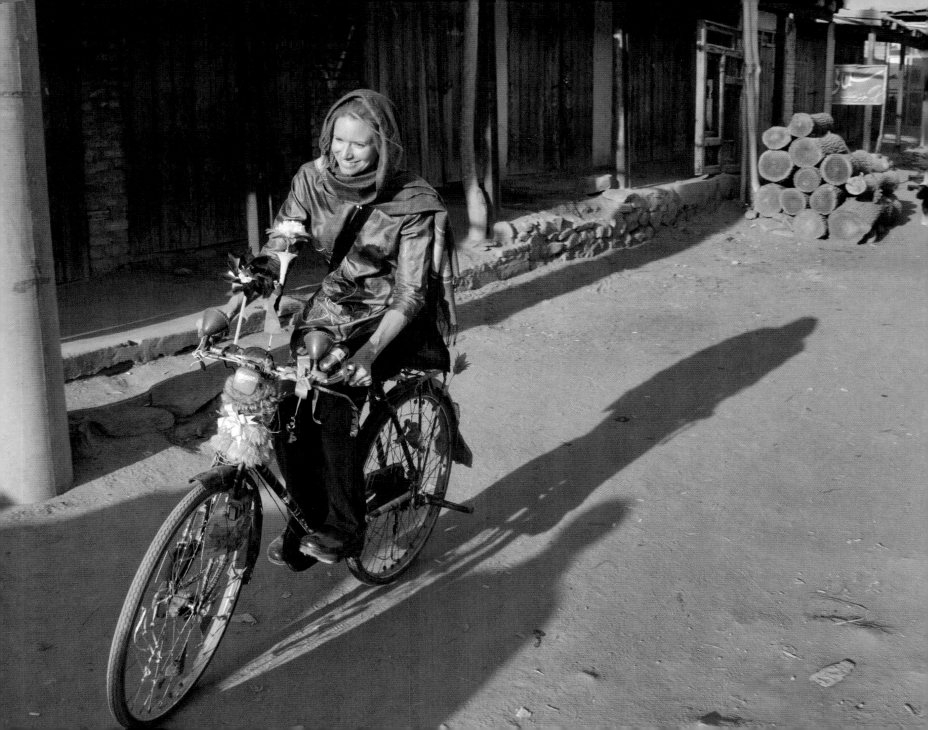

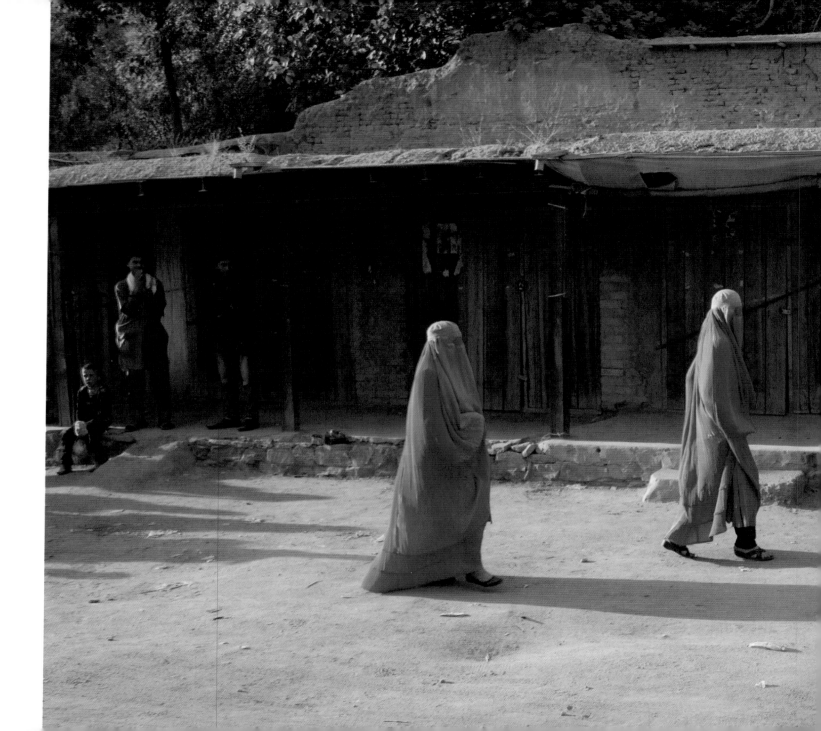

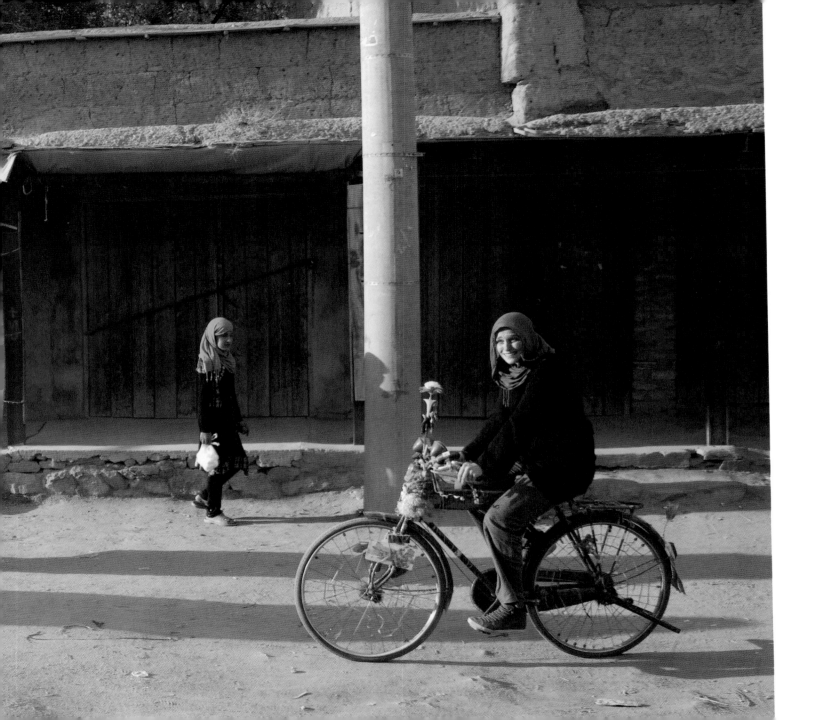

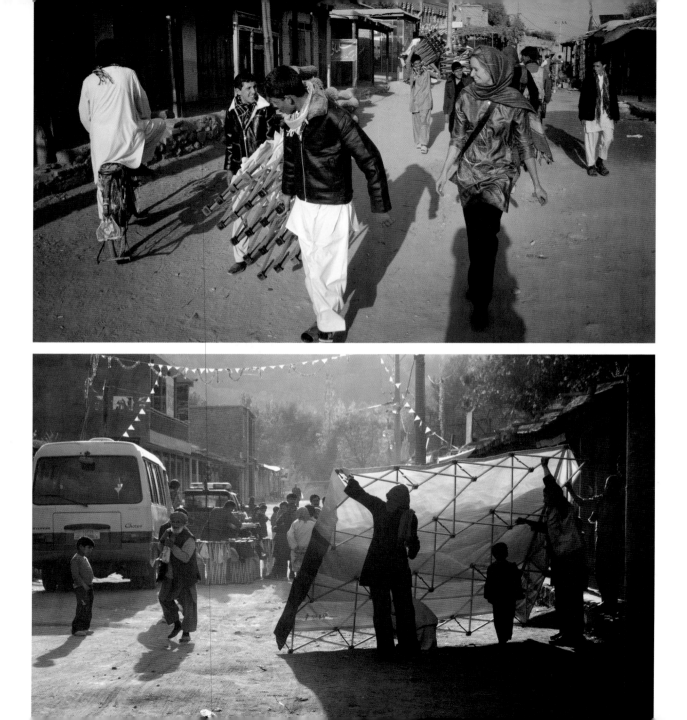

After a late lunch of lamb stew, fresh naan, and green tea, we started to take the exhibition down. While the locals had stood back curiously and watched while we were setting up, after the hours of walking around the images and random conversations with us, they were excited to get involved to help take down the images and be part of the process.

The villagers and soldiers shook our hands, and waved us off. It was all smiles, even from Najibullah, as we boarded the bus to head home.

Stopping at a bend in the road overlooking the valley at sunset, the excitement and relief of the exhibition was nearly bursting out of us. Thus, Anna and I took our first of many jumping photos together to celebrate.

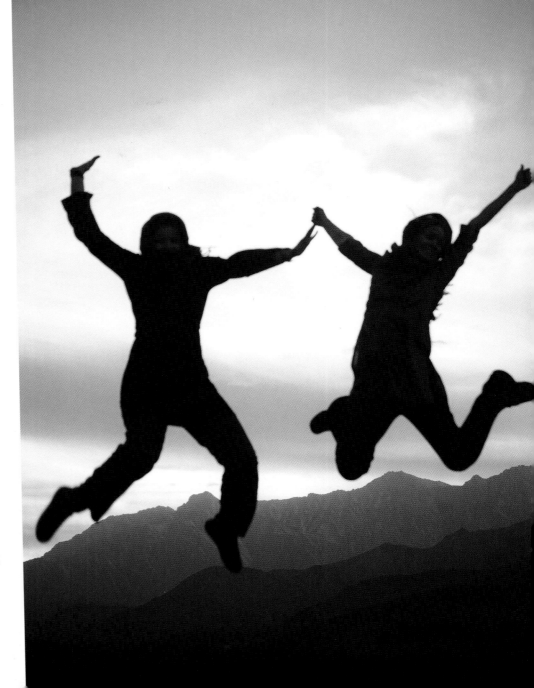

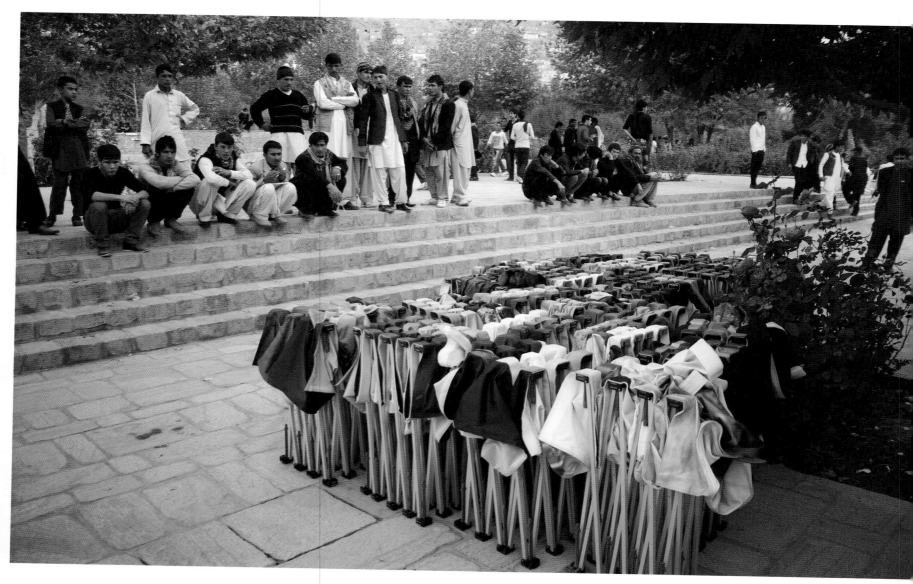

Streets of Afghanistan

BABUR GARDENS

The next four days saw us complete three more exhibitions in Kabul's public spaces and famous landmarks: Babur Gardens, Kabul Zoo, and the Women's Garden.

The Babur Gardens exhibition was set up on the second day of the Eid celebration and was our largest and most public exhibition of the series.

Babur Gardens, locally called the Bagh-e Babur, is a historic park in Kabul that is thought to have been developed around 1528 A.D. The gardens are the last resting place of the first Mughal Emperor, Babur. They are a source of great pride in Kabul and the park is usually filled with families, especially on Fridays and holidays.

We arrived early to unload before the gardens opened, but by the time we were setting up in the main courtyard, a crowd was already gathering. Over 2,000 Afghans came through the gardens that day. The majority were men, but many families came together to picnic, celebrate the holiday, and enjoy the warm weather and sunshine.

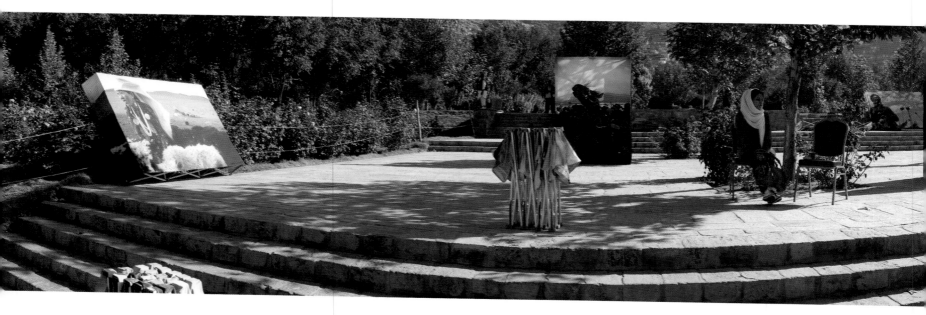

Streets of Afghanistan

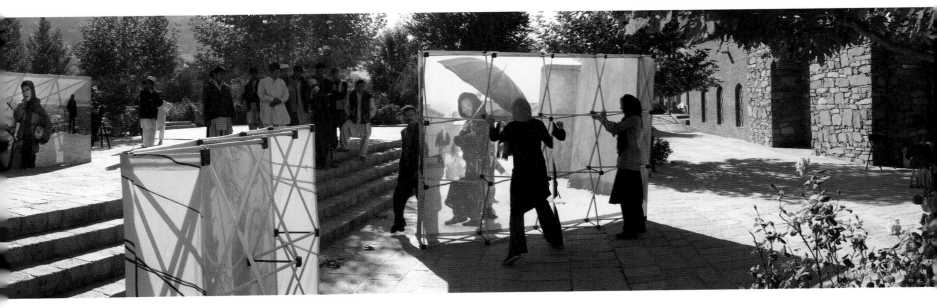

Kabul

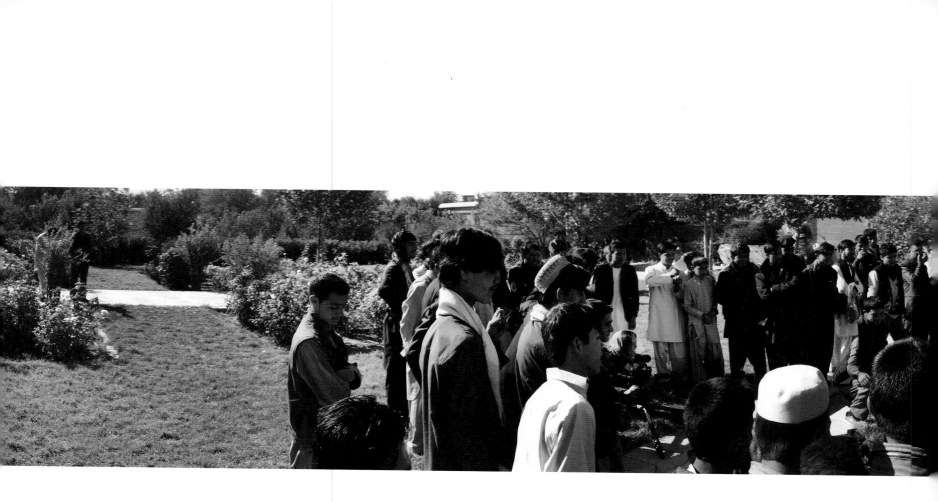

Streets of Afghanistan

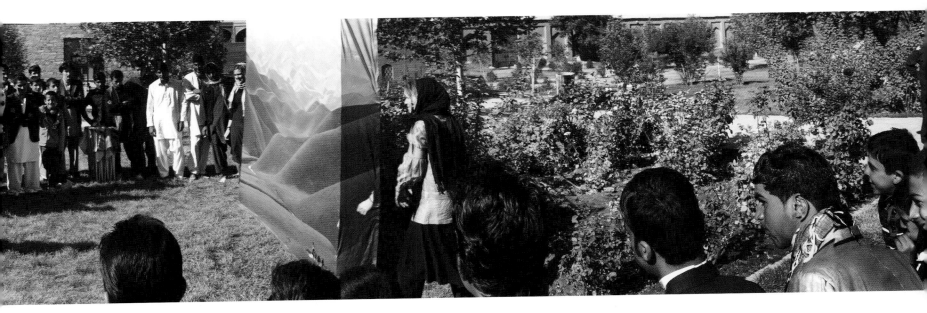

Kabul

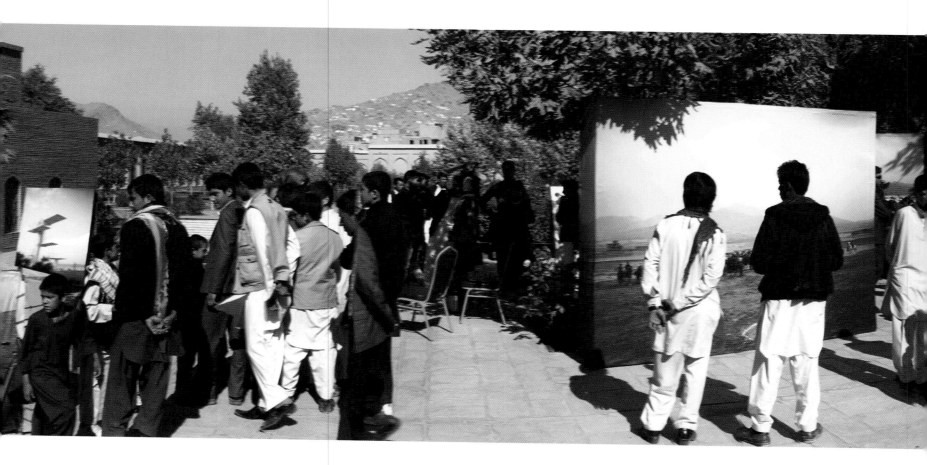

Streets of Afghanistan

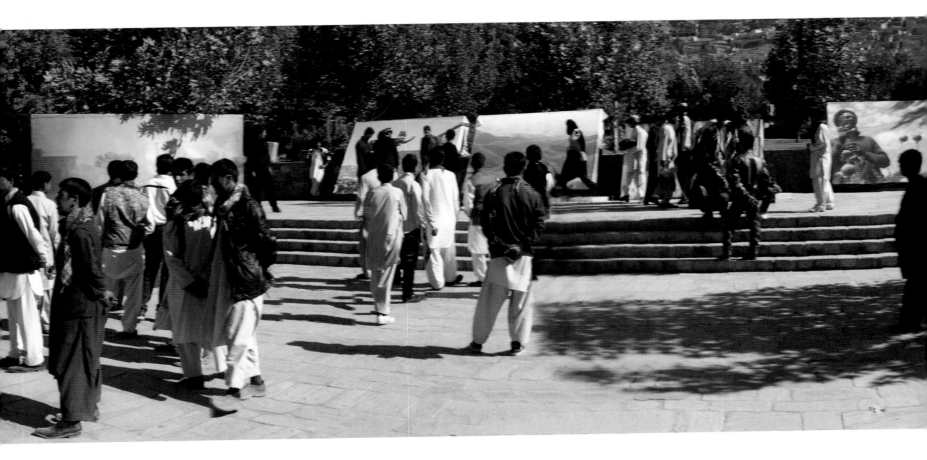

Kabul

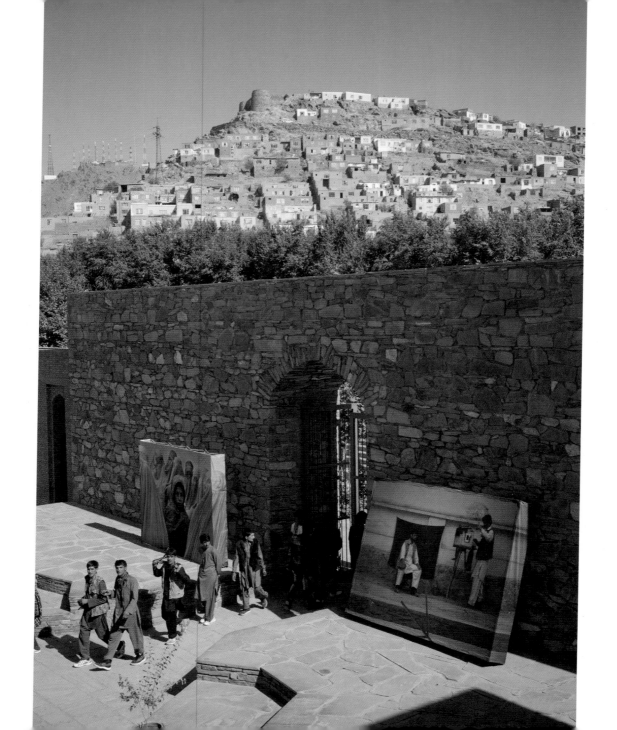

The most common interaction with the exhibition was the constant use of cell phone cameras to take photos with the images. Many took photos in front of the landscapes of Bamiyan by Beth Wald, as though placing themselves inside a tourist photo. Many others took in the images more quietly.

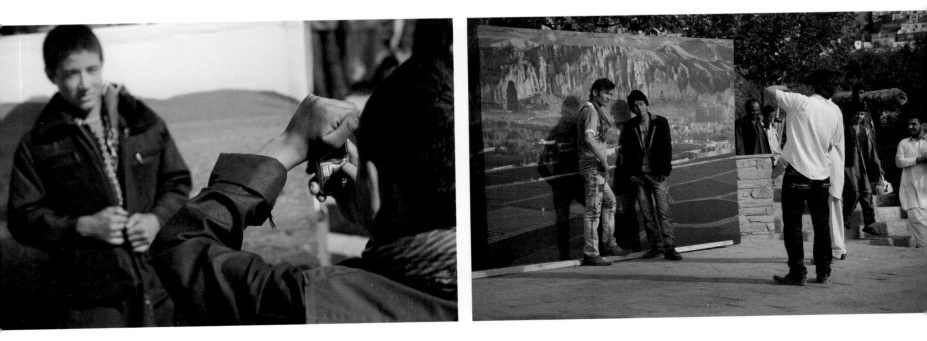

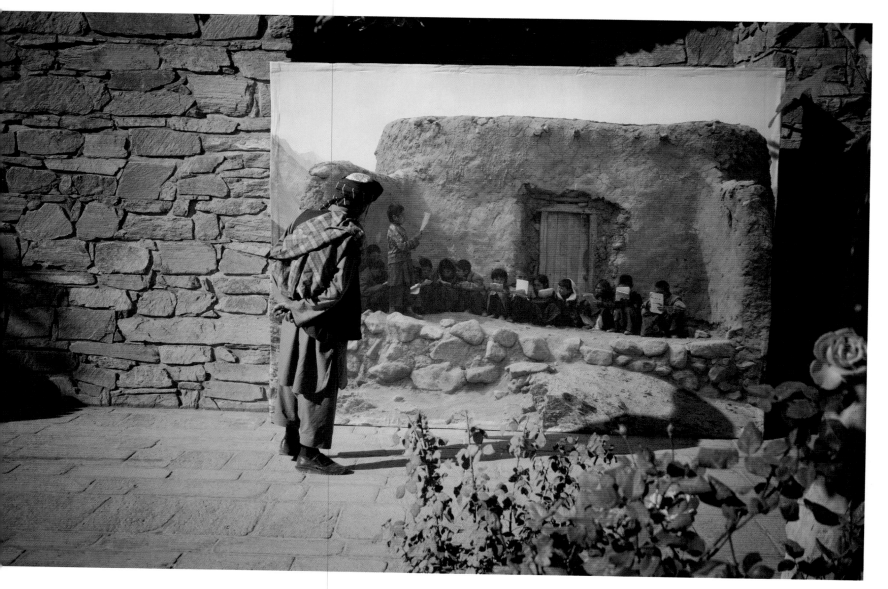

Streets of Afghanistan

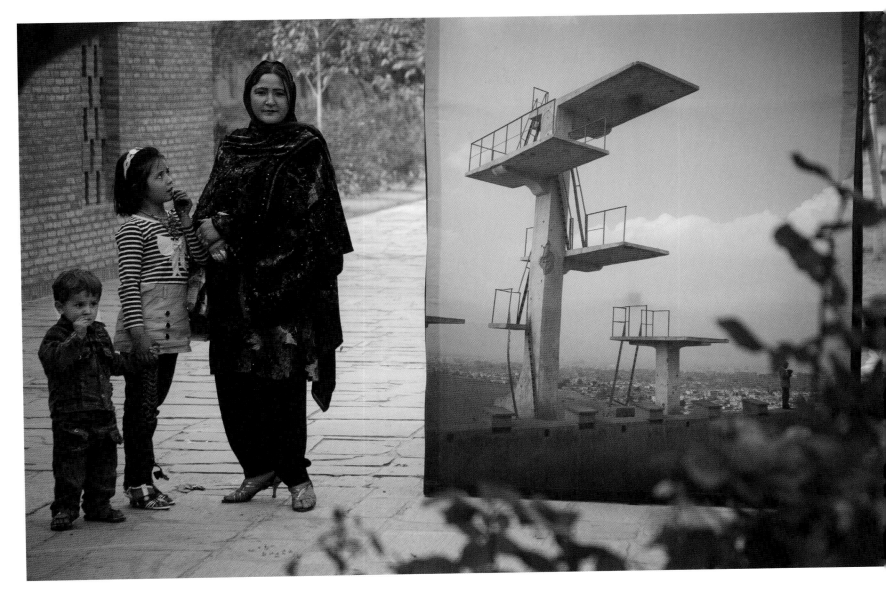

Kabul

Kabul Zoo

The next day was the infamous Kabul Zoo. This was an interesting place to hold an exhibition, but as one of Kabul's most visited public spaces, it meant that we would reach a large number of Afghans on the final day of Eid.

The zoo rests along the banks of the Kabul River, and was opened in 1967. In the 1970s it had 500 animals. Years of occupation and civil war destroyed much of the zoo, and many of the animals were killed for food. The Kabul Zoo became famous among Afghans and foreigners for the tale of its lion, Marjan. The Germans gave Marjan to the zoo in the late 1960s, and Marjan was the pride of the institution. In

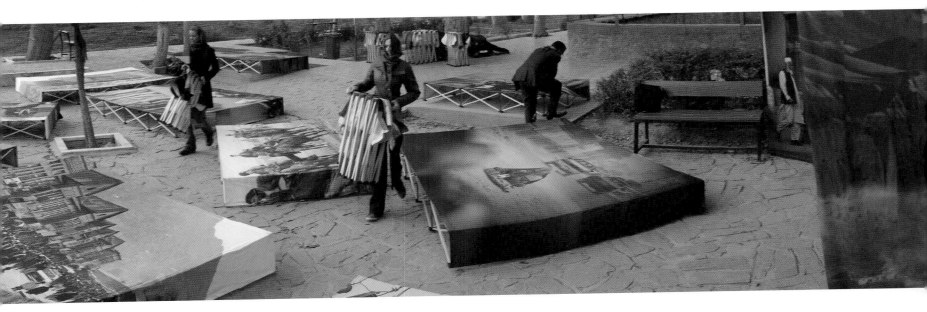

1993, a Taliban soldier had a strange idea of slipping into his den, and was killed by the lion. The next day, the victim's brother took revenge by throwing a grenade at the lion's snout. Marjan lost one eye and his teeth, but survived. He died in 2002 of old age and today the statue out front of Marjan immortalizes him as a hero and a symbol of Afghan pride.

Today, there are around 280 animals, including Afghanistan's only pig. Approximately 10,000 Afghans come through the zoo on most weekends, and like the day before in Babur Gardens, many people were out enjoying the good weather and public holiday with their families on the final day of Eid.

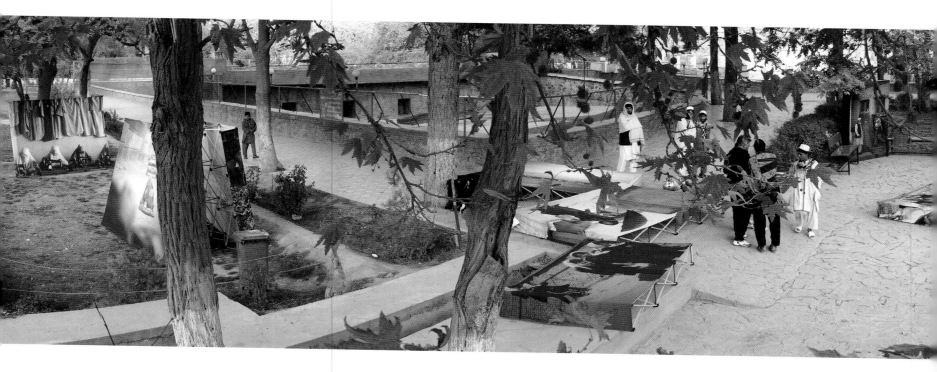

Streets of Afghanistan

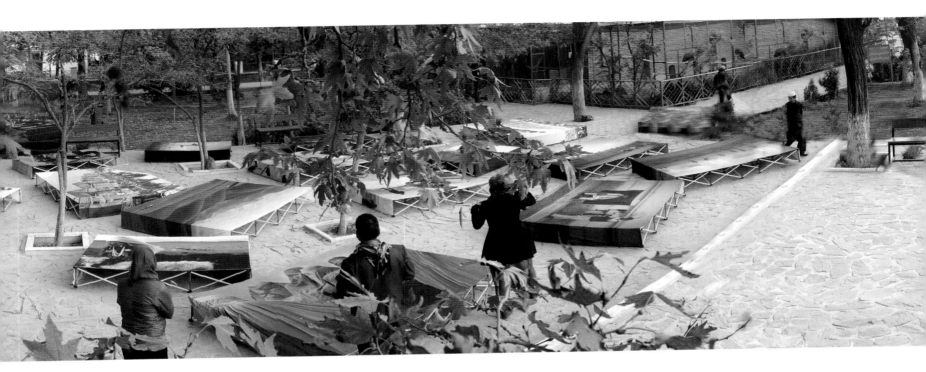

As was becoming the typical early morning set-up, the configuration of each new space was the biggest challenge. Kabul Zoo had the unique challenge of most of the "wall space" being the front of the animal enclosures. We simply unfolded onto the ground and tried to visualize something that would work in the small courtyard in between the bears and the monkeys.

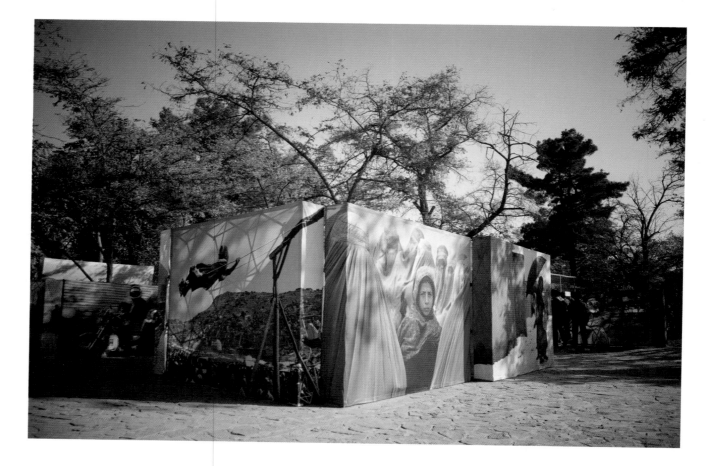

We figured out a series of cube configurations around the trees that created a more stable set-up than Babur Gardens as we could tie the frames together behind the scenes. Just in time for the crowds that started to pour in.

Streets of Afghanistan

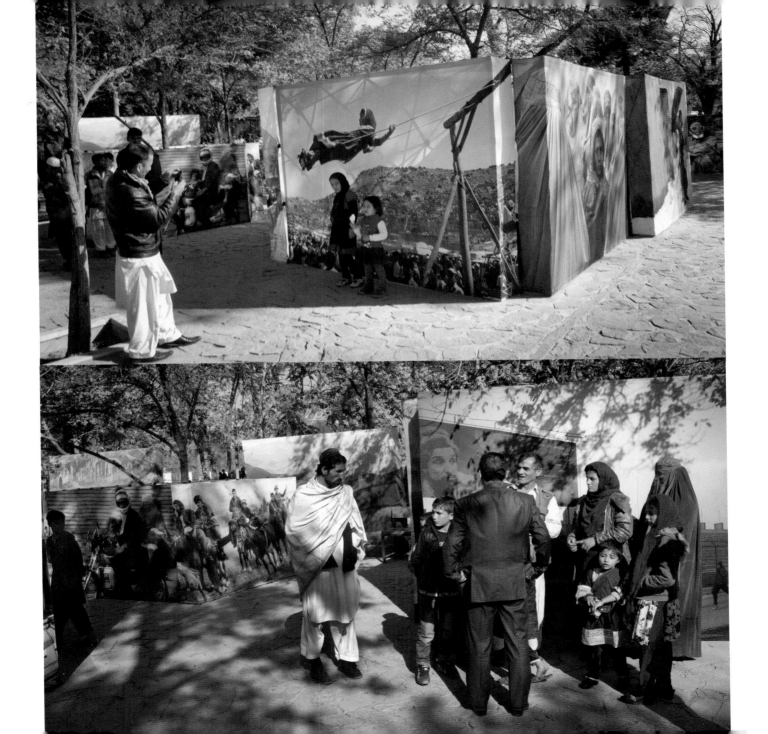

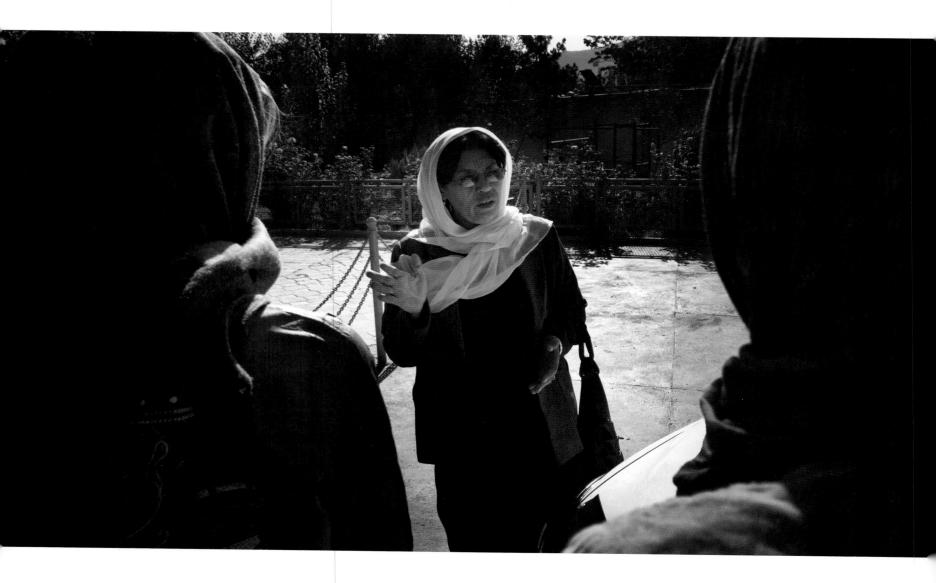

Streets of Afghanistan

KABUL WOMEN'S GARDEN

The Women's Garden is a woman-only park that was closed in Taliban times and turned into a city dump. The garden re-opened in 2011, and today it is an 8-acre oasis for women to freely roam in peace inside Kabul. Inside the walls are 5,000 rose bushes and 3,500 trees. This is more than just a park of fountains, gazebos, and playgrounds. It also contains a small market of shops, a fitness center, basketball court, kindergarten, restaurant, mosque, computer lab, and job training centers (including a driving school), all managed by women for women.

The head of the Women's Garden was a gracious host and a pleasure to work with. She had several favorites among the photos, which we plan to donate to her after the final show to keep permanently at the garden.

The layout of the gardens with many small pavilions and walkways made the set-up incredibly challenging. We kept the photos inside the wheeled bags to make them easier to transport to the various corners of the park.

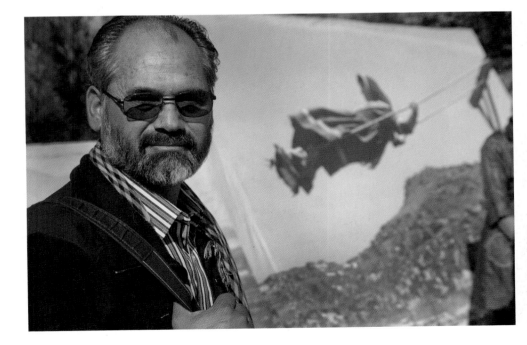

Two of the Afghan photographers in the exhibition, Najibullah Musafer and Wakil Kohsar, were both able to visit the gardens as members of the press to see the exhibition. Both photographers are now working with other agencies as full-time photojournalists.

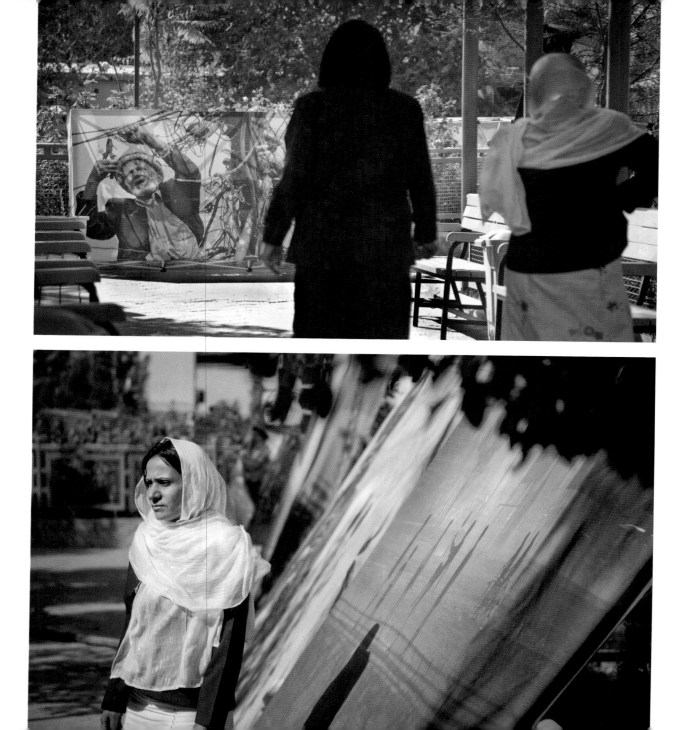

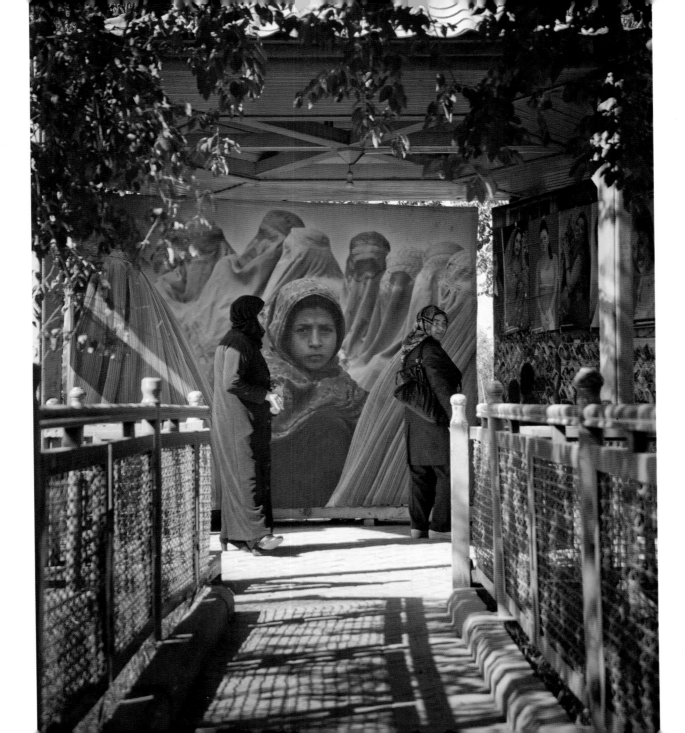

The best part of this exhibition was the women. While it was a quiet day in the garden, there were women visiting and we got to speak with many of them without the press of hundreds of men surrounding us.

We celebrated the completion of the fifth exhibition with a picnic lunch with the crew and friends in the garden—lamb kebabs, fresh yogurt, and bolani with endless pots of green tea in a sunny spot on the grass. After three days in a row of setting up and taking down the massive installation in various parts of Kabul, it was a welcome reprieve.

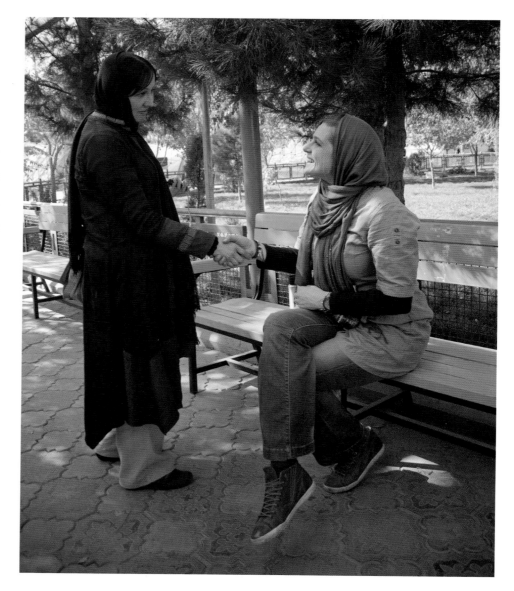

Streets of Afghanistan

One of the highlights of the women's garden exhibition was meeting a long-time Kabul ex-pat I had heard a lot about. Mary has lived in Kabul since the 1960s and is one of the few, if only, Americans to have entered Afghanistan during the peaceful travel booms of the sixties and stayed. She has witnessed the Soviet occupation, the civil war, and the Taliban times, and has no plans to leave. One of the few foreigners, and only woman I know of, Mary continues to ride her bike and walk around Kabul daily, and her stories beg for a separate book just to contain them all.

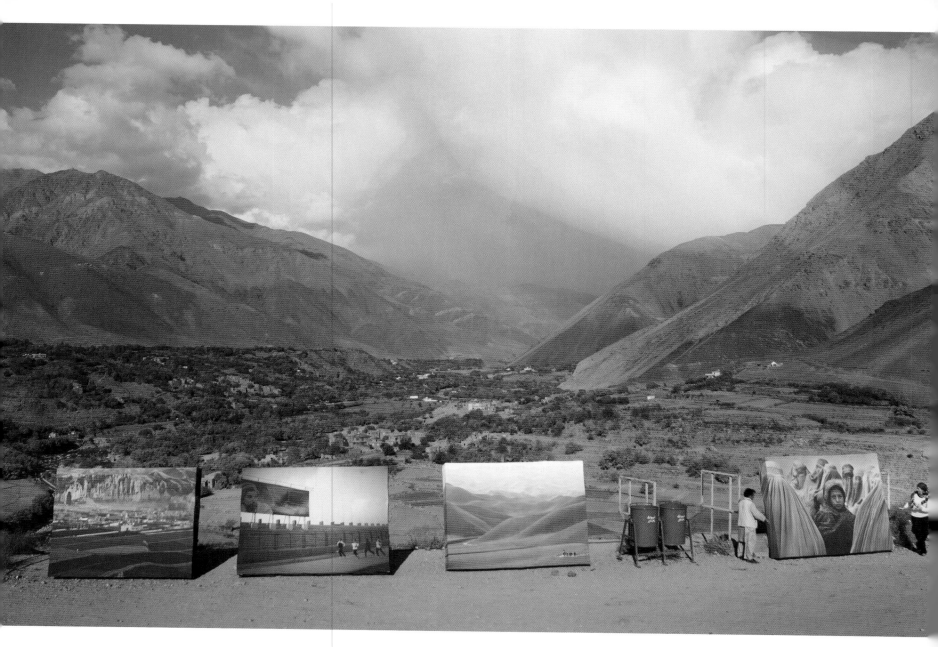

Streets of Afghanistan

Panjshir Valley: Massoud's Tomb

PANJSHIR VALLEY, THE VALLEY OF THE FIVE LIONS, lies 150 kilometers north of Kabul, near the Hindu Kush Mountains. It is one of the most beautiful and peaceful provinces in the country, the only corner of Afghanistan that has never be taken over by the Taliban. The province is famous for its emerald mines and frequently on prior visits I have had men pull fistfuls of raw green stones from the mines out of their pants pockets to show me proudly.

Panjshir is home to Afghanistan's immortal hero, leader of the Northern Alliance, and Panjshiri source of pride, Ahmad Shah Massoud. Massoud fought for a free Afghanistan for 20 years, before being assassinated by Al-Qaeda in September 2001, a few days before 9-11. His tomb is on a hillside overlooking the valley near his home in the village of Jangalak. I had visited Panjshir and saw the first stages of the tomb construction in my visit with Libero in 2008. Faheem Dashty is from Panjshir, and was the press secretary to Massoud. He himself was severely injured by the bomb that killed Massoud. Faheem had invited us to have lunch at his family's home and meet his father, General Dashty. He then took us for a drive to

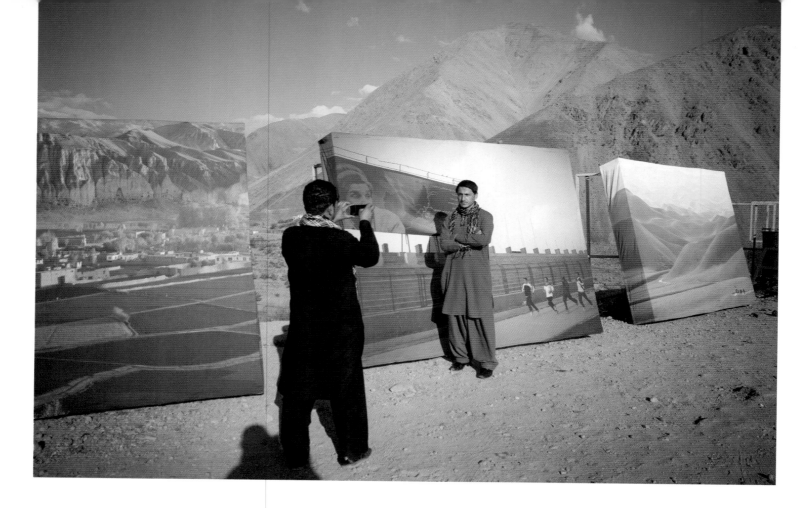

see Massoud's home and visit the tomb to pay respects. Since then, it has become my favorite corner of the country and one that I have explored by car, motorcycle, mountain bike, foot, and with fishing nets.

As we set up, a man in pale brown shalwar kameez asked in perfect English what we were doing and what was the purpose of the photos. After a long discussion, we discovered that he was a colleague of Faheem Dashty and was in Panjshir to see family and pay respects at the tomb.

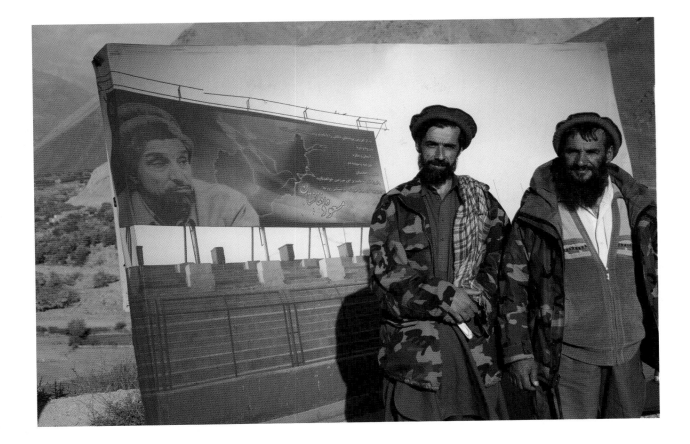

Two of Massoud's men who stand guard at the tomb were proud to stand next to Libero's image of Kabul Stadium where a billboard bearing Massoud's face presides over the track.

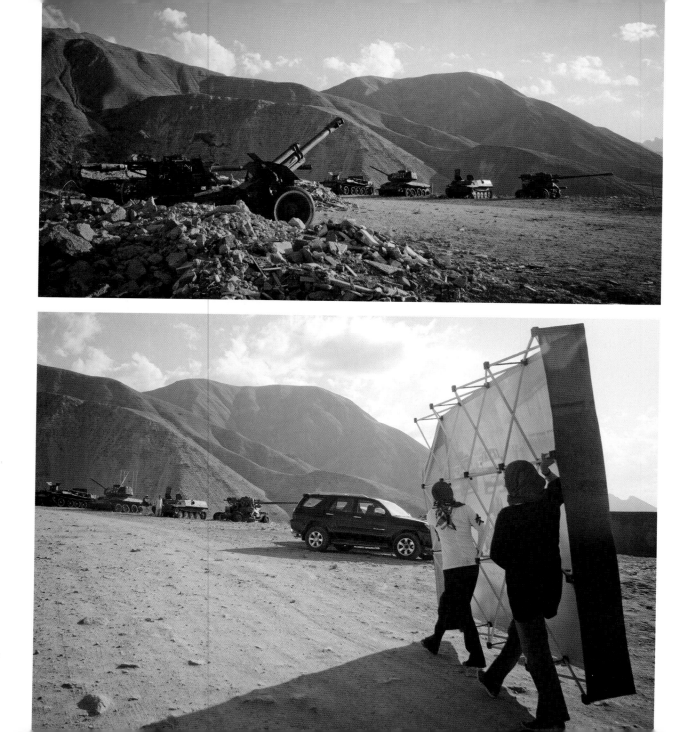

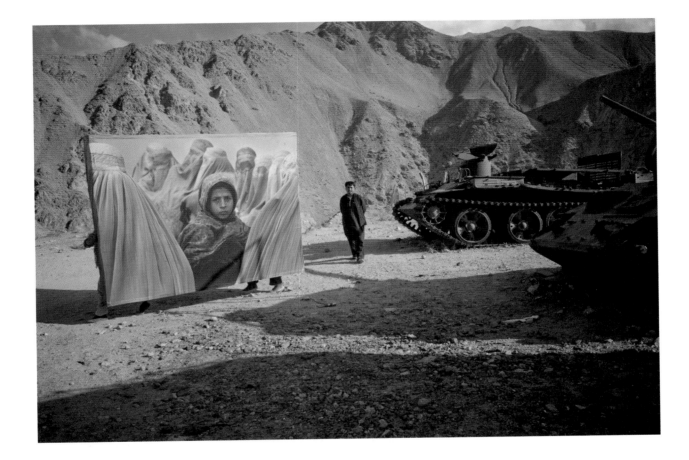

Looking for a second area to set up more of the exhibition, I spied the small tank graveyard and asked Massoud's men whether it would be okay if we propped up the images against the tanks, using the tanks as easels. They laughed and agreed. Having seen small children climb on the tanks, swinging from the gun barrels like jungle gyms, I loved the idea of using something so combative for another purpose.

We realized the images wouldn't withstand the wind as they were and we couldn't just ask people to stand for hours between the tanks and the images to hold them in place, so instead we positioned them against the walls of Massoud's tomb. They provided a burst of color and hope against the stark marble and somber tone of his hillside resting place.

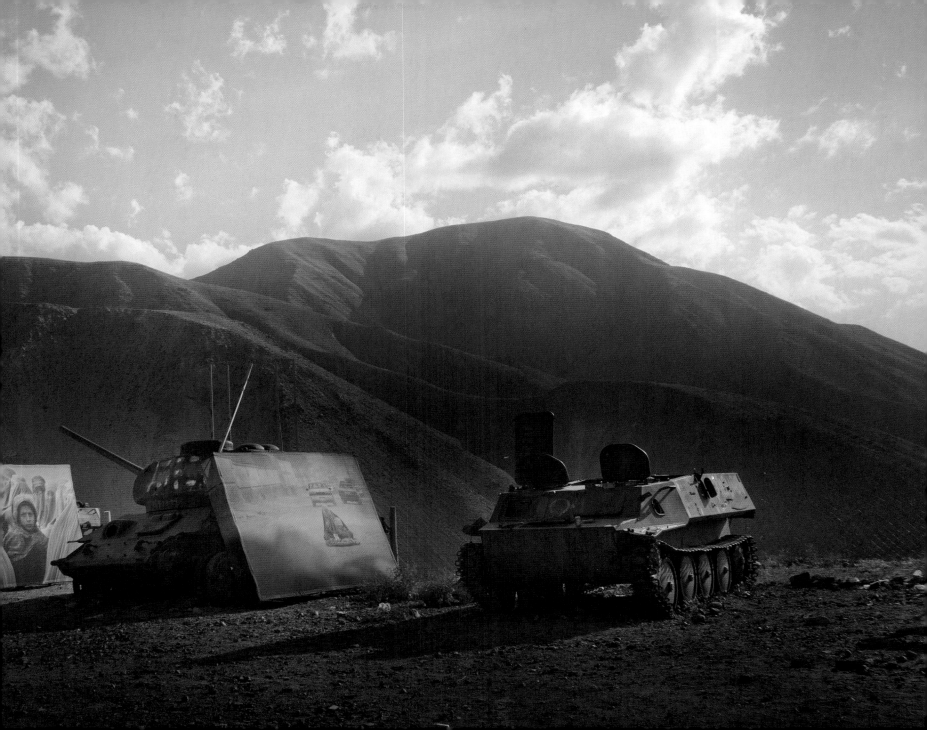

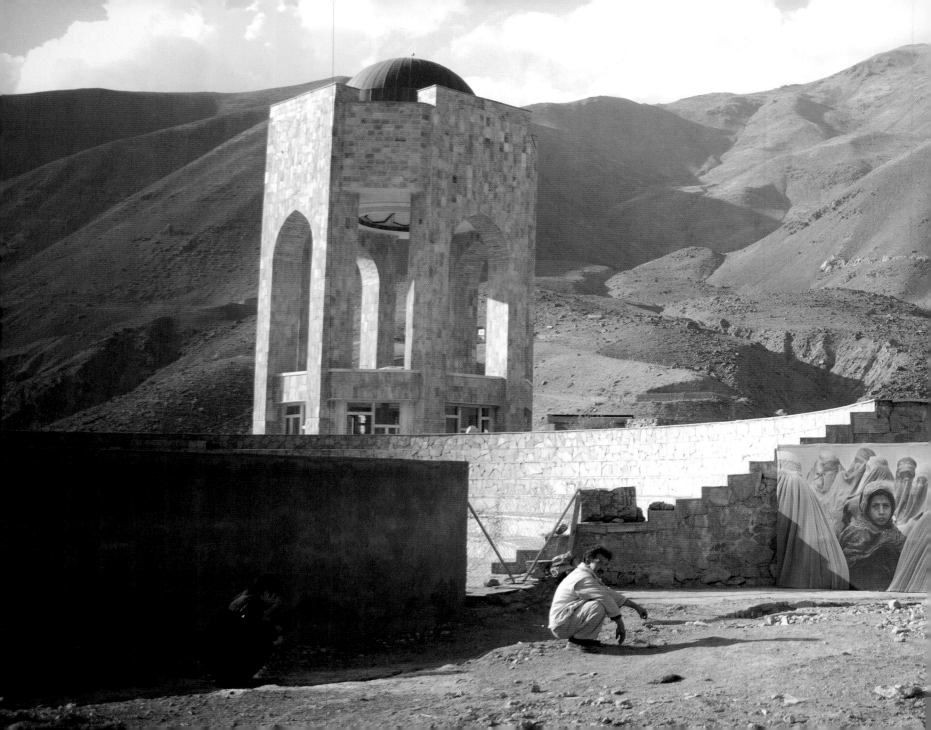

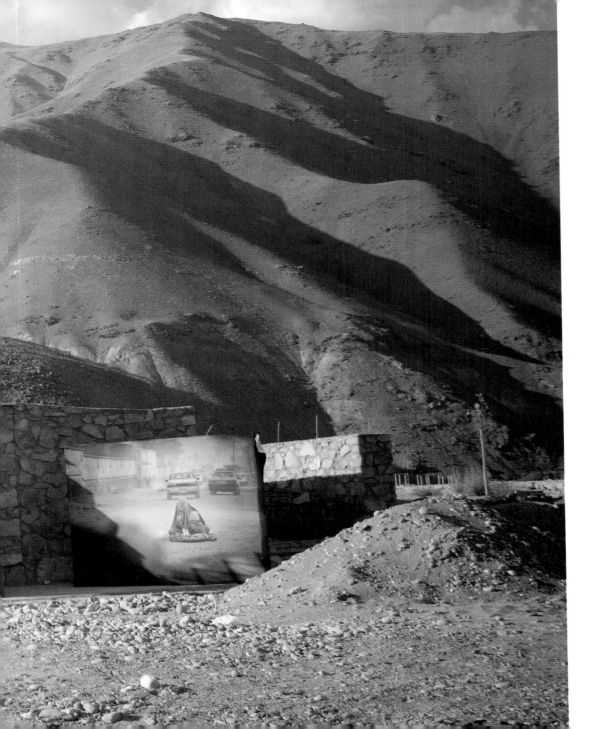

As the sun began to set, we took down the images and said farewell to Massoud's spirit and to the soldiers.

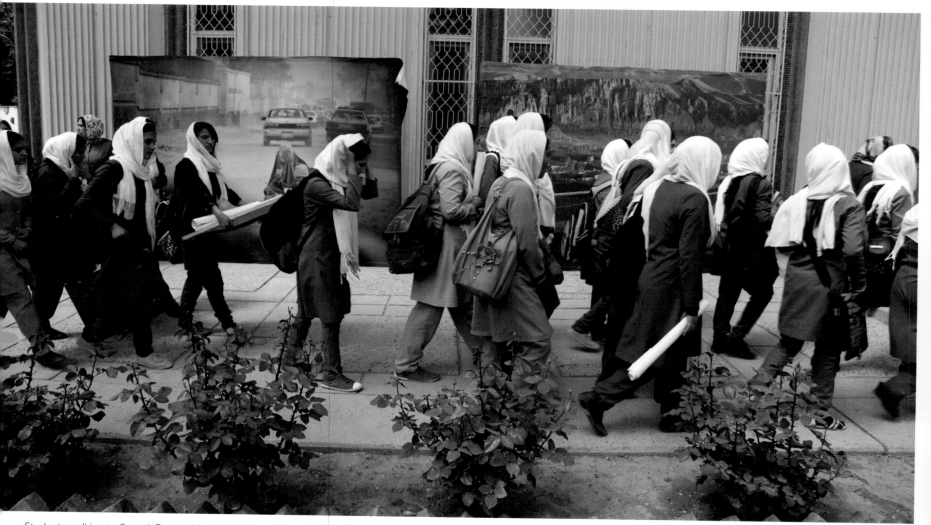

Students walking to Sound Central Music Festival on Women's Day. *Photo credit: Mariam Alimi.*

Finale Exhibitions:
U.S. Embassy and
Sound Central Festival, Kabul

THE FINAL SHOWS WERE PUBLIC EVENTS that used the exhibition as a backdrop. The first was a show at the U.S. Embassy as part of their celebration and remembrance day for Daniel Pearl. The images set the backdrop for a rooftop rock concert with several Afghan bands, including heavy metal Afghan rock band District Unknown, female rapper Soosan Firooz, and other Afghan musicians.

Five months later, we returned to Kabul for the finale exhibition as part of the Sound Central Festival. The images set the backdrop for all the visitors coming to the three-day alternative music and arts festival founded by dear friend, photographer, filmmaker, and rocker, Travis Beard.

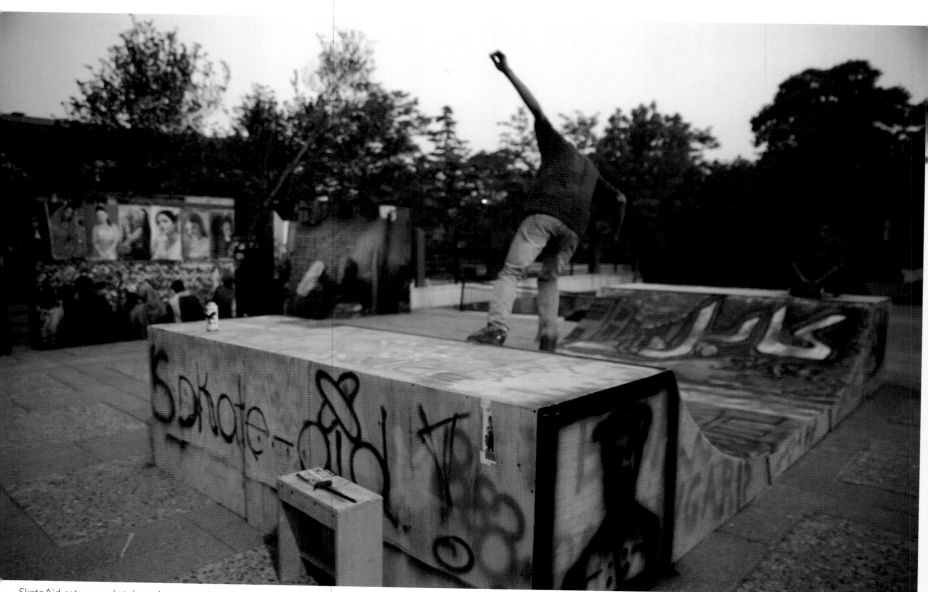

SkateAid sets up a skateboard ramp at the entrance to the Sound Central Festival. *Photo credit: Ellie Kealey.*

Streets of Afghanistan

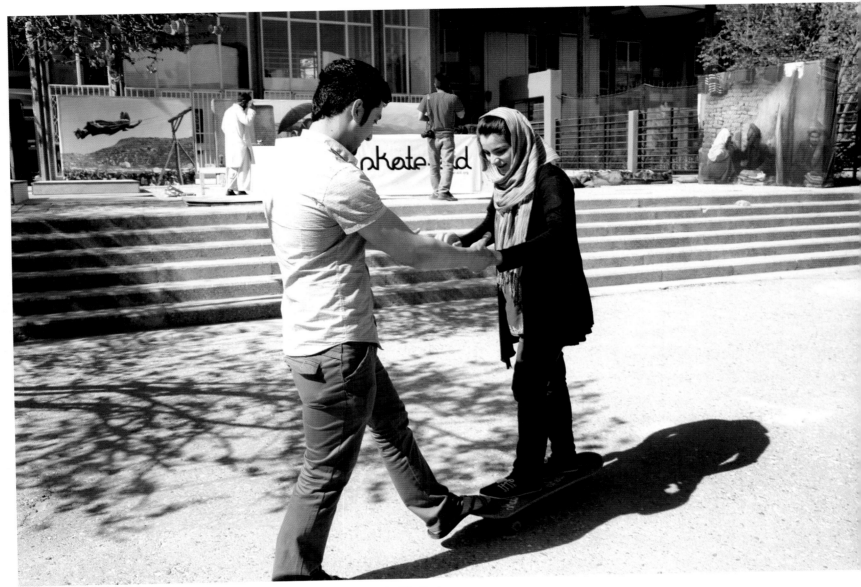

Afghan girls learn to skateboard outside the Sound Central Festival.. *Photo credit: Ellie Kealey.*

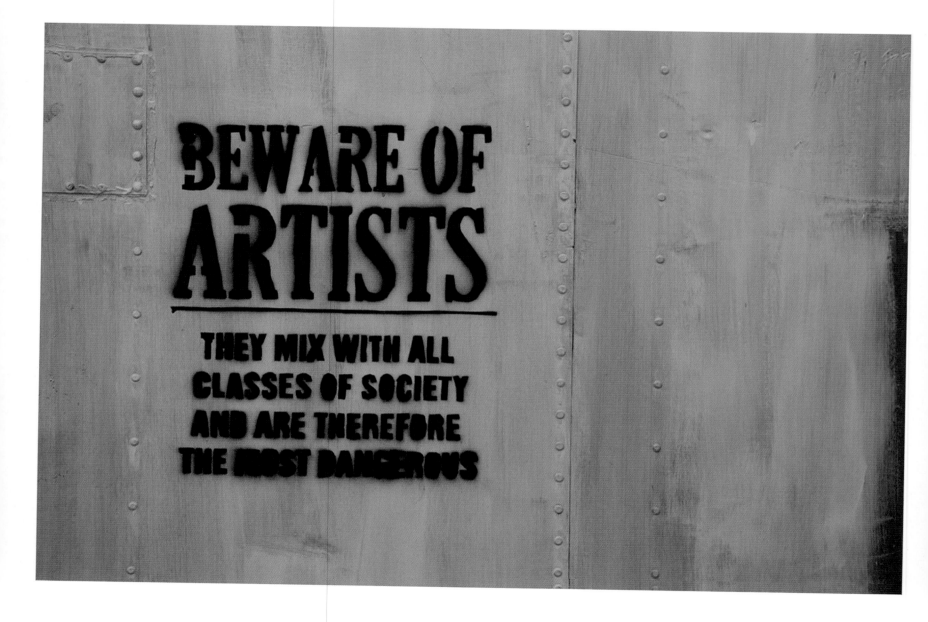

Conclusion: Art as Activism

Public art isn't just for New York, London, and Paris. If anything, public art is even more important in countries like Afghanistan because the ongoing war is not the only story. Poverty, oppression, and lack of infrastructure are the canvas on which life occurs, and that story needs to be told as well. Photography can tell that story better than any other medium because there are no limits to its interpretation.

So why spend the money, and take the time and risks to do a public show without security and restrictions in public spaces and villages throughout Afghanistan? Because this is where art is most needed.

This country deserves to be exposed to beauty and art for the same reasons as anywhere else. The world needs to see that a space for art is emerging in Afghanistan and to be reminded over and over again that this is a country filled with amazing people living their lives against an incredibly difficult backdrop.

In the end, the goal of Streets of Afghanistan was to show that art has a place in conflict zones. That Afghans deserve the same access to art and beauty we all crave. That shows like this can be done safely and publicly in Afghanistan for Afghans, not closed off behind compound walls, accessible only to the

Embassy and international community. Art has the power to inspire and create a ripple of change that resonates through communities. Public art serves the purpose of bringing art out of private places and into public spaces among people that are least likely to engage with art.

The space for art in Afghanistan is emerging with graffiti artists, rock musicians, and a beautiful addition of Kabul to the worldwide global project Inside Out by JR, which was completed during this visit by a handful of visionaries and friends. Step by step, this country can be more than it is today, and art and voice play heavily in engaging community and combating apathy. It was such an honor to be part of this emerging community of Afghan artists and dreamers.

<center>❖</center>

A huge and heartfelt thank you to all the photographers involved: Beth Wald, Travis Beard, Ann Curry, Libero Di Zinno, Paula Bronstein, the late Paula Lerner, Wakil Kohsar, Najibullah Musafer, Gulbidden, and Miriam Alimi. I was honored to pull your beautiful images together for a groundbreaking exhibition that showcased your talents and the beauty of Afghanistan. It was an honor to work with your images, to be trusted with them. I am forever in your debt.

It was a huge shock to hear of Paula Lerner's passing. She spent much time in Afghanistan and particularly with Afghan women. Many of her iconic photos show the sweetness of the Afghan people not often captured. She generously agreed to be part of this exhibition and we had talked about having her present at one of the shows. I wish she could have seen the finished product, as I was so honored to have her agree to be part of the exhibition. More than that, I wish she could have been with us in Afghanistan when we

toured the images. Najibullah, our translator, worked with Paula as well and has fond memories of her. We spoke about her during the set-up and take-downs each day, and in some small way, I felt like she was with us in spirit.

Jumping high-fives to Anna Brones for saying yes to joining me on this journey to Kabul. The promise of the best kebabs in Kabul, fresh pomegranate juice, and Le Bistro's fabulous fig croissants worked wonders on this avid food writer and founder of Foodie Underground. Your humor and passion for food and adventure made this particular visit unforgettable.

Thank you, Libero Di Zinno, for accompanying me on the first trip in 2008 and documenting my first steps in a country I have now returned to over a dozen times. It is wonderful coming around full circle to have many of your images from that trip in the exhibition itself and to have you join me a second time—four years later—to document the exhibitions as they were intended, in the streets. Your friendship and talent beyond the lens are incomparable.

The Photographers

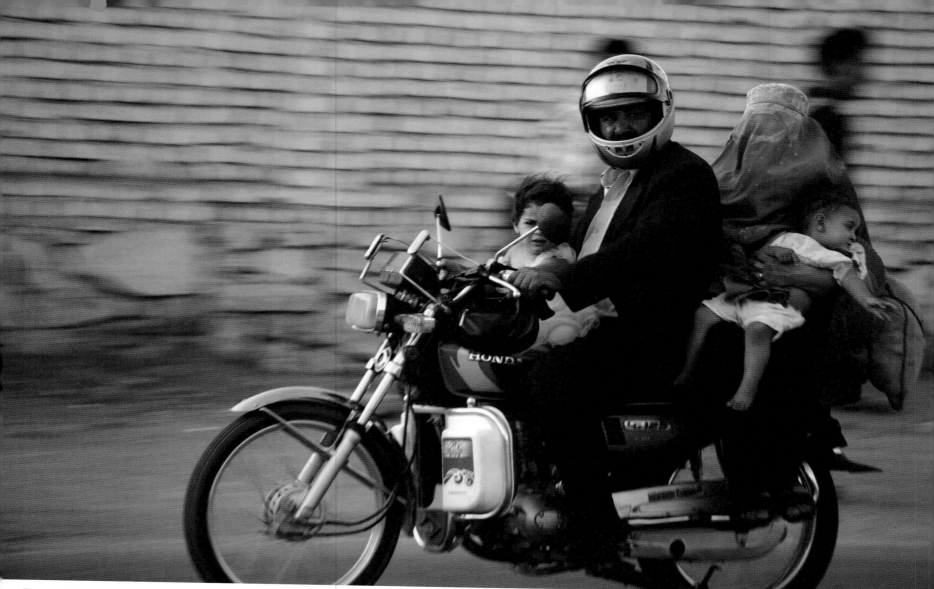

TRAVIS BEARD
FAMILY ON MOTORCYCLE, KABUL.

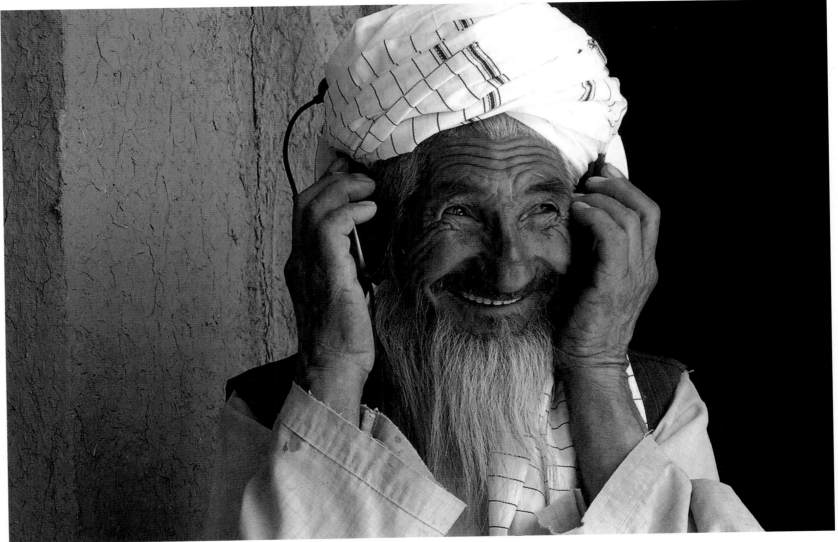

MARIAM ALIMI
AFGHAN FARMER, HERAT.

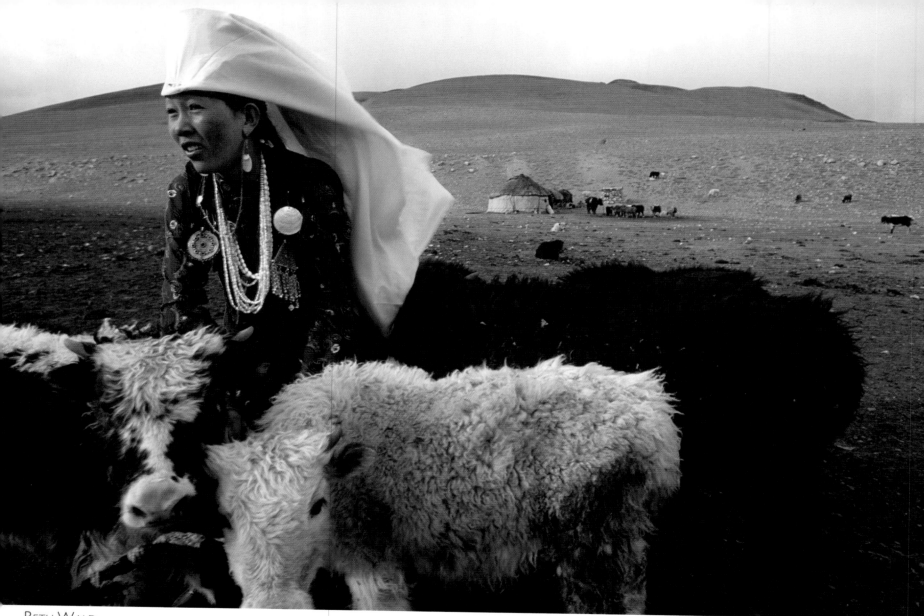

BETH WALD
KYRGYZ NOMAD GIRL, WAKHAN.

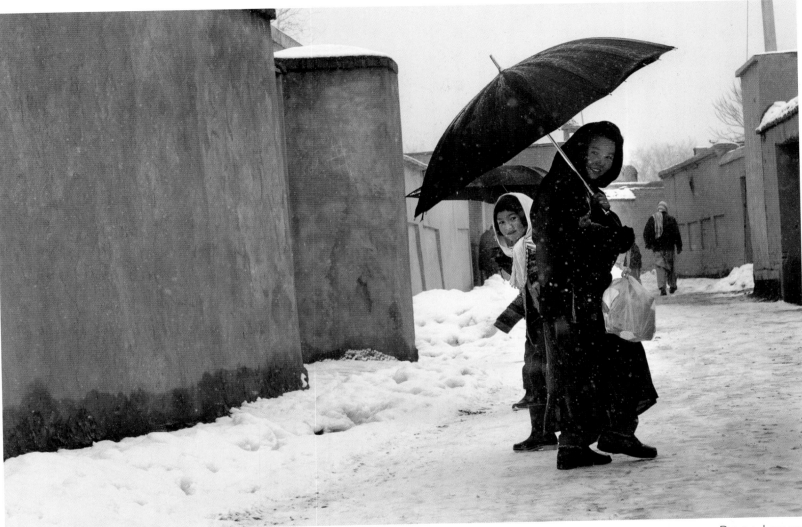

PAULA LERNER
GIRLS WALKING HOME IN SNOWSTORM, KABUL.

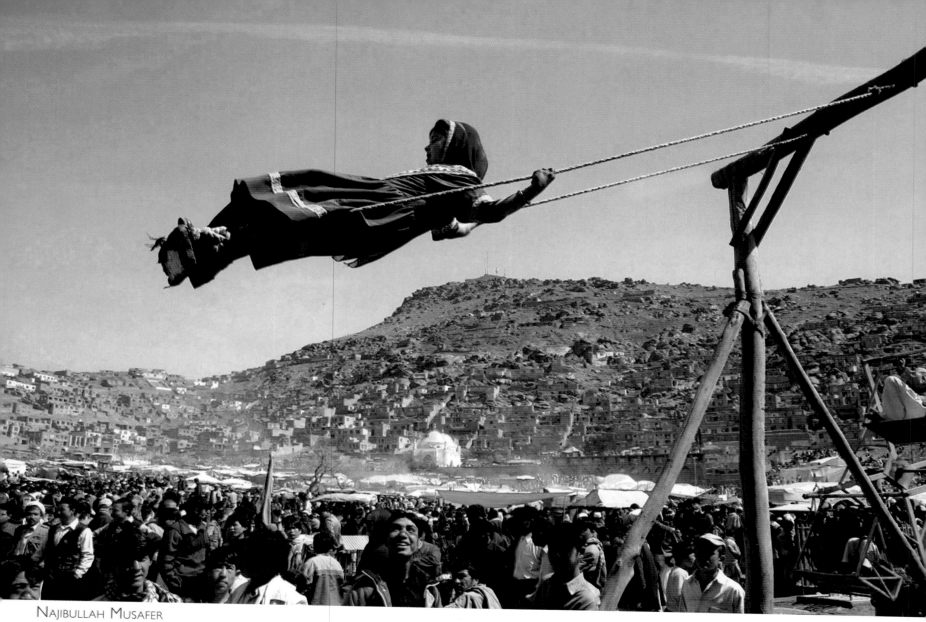

NAJIBULLAH MUSAFER
GIRL ON SWING AT FESTIVAL, KABUL.

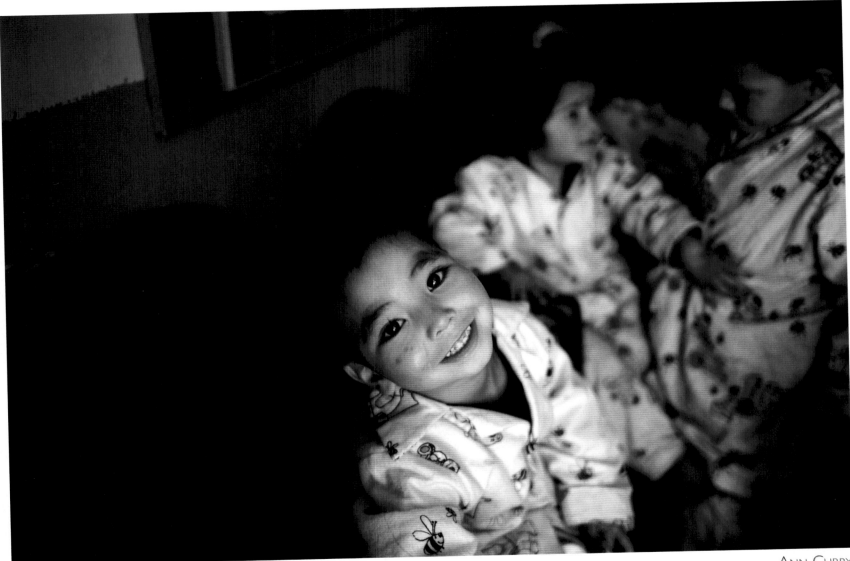

ANN CURRY
CHILDREN AT THE KABUL WOMEN'S HEROIN REHAB CENTER.

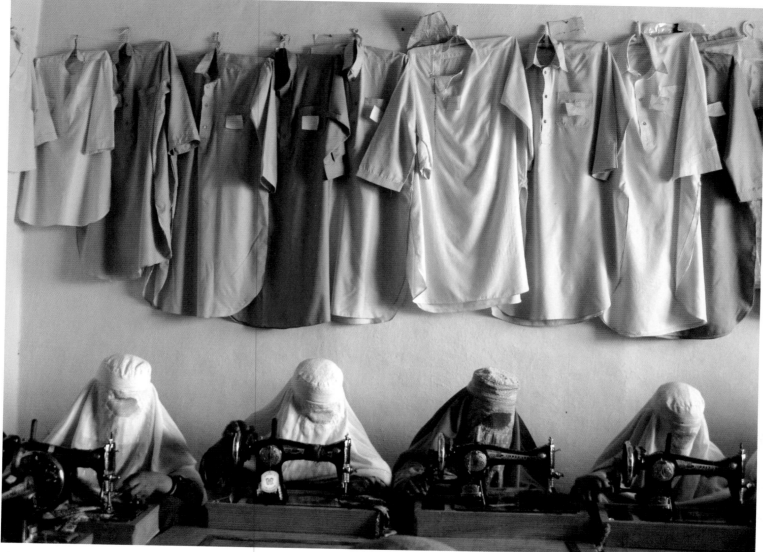

GULBIDDIN
WOMEN WORKING, KABUL.

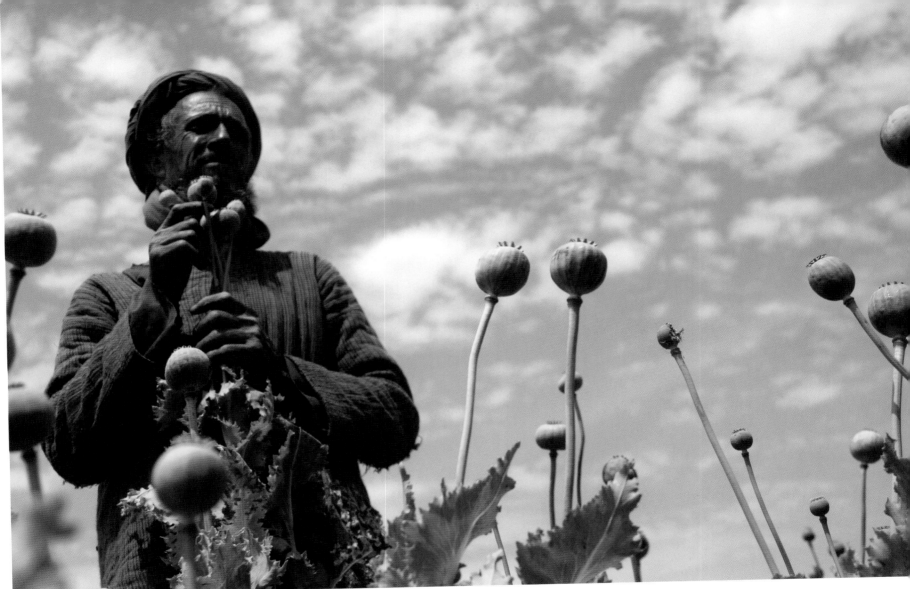

WAKIL KOHSAR
FARMER IN OPIUM FIELD.

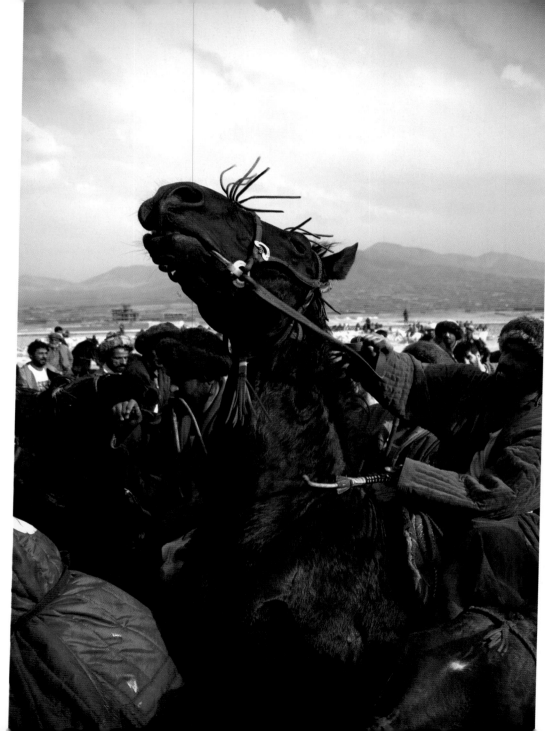

LIBERO DI ZINNO
BUZKASHI HORSE, SHOMALI PLAIN.

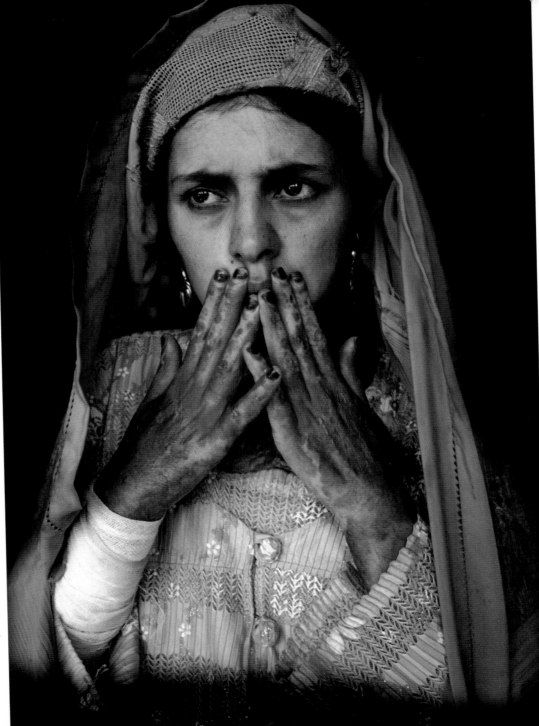

PAULA BRONSTEIN
SELF IMMOLATION SURVIVOR, HERAT.

About the Authors

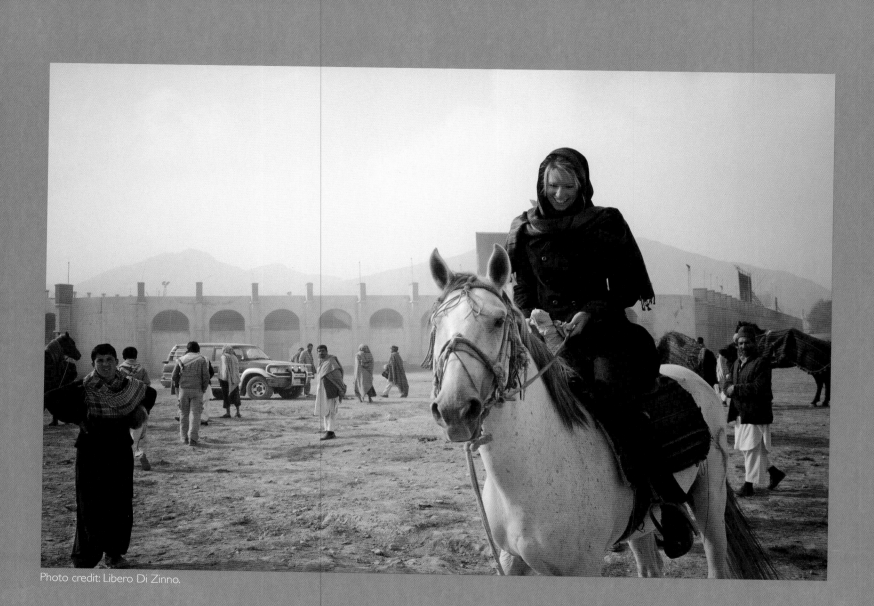

Photo credit: Libero Di Zinno.

SHANNON GALPIN

National Geographic Adventurer of the Year, Shannon Galpin, founded the Colorado based non-profit, Mountain2Mountain, in 2006. Believing that connecting communities on both sides of the equation was key to combating the apathy that prevents action and that changing perceptions was just as important as tangible projects, she developed projects that involved communities and provoked discussion through art, music, and sport. Supporting graffiti art projects in Kabul and creating the Streets of Afghanistan life-sized photography exhibition, Shannon has focused on projects that empower voice and inspire others to combat apathy. While visiting the women inside Afghanistan's Kandahar prison, Shannon was confronted with the power of voice, which became the backbone of all her work going forward. In 2009, she became the first woman to mountain bike in Afghanistan, a country where the culture does not allow women to ride bikes. Along the way, she always has a silver barrette given to her by one of the women inside the Kandahar prison—a piece of that woman freed as Shannon fights for the rights of women and girls around the world. Shannon is currently writing her memoir to be published in the fall of 2014, and is the producer for the upcoming documentary, Afghan Cycles, with Let Media about the Afghan National Women's Cycling Team. Visit www.shannongalpin.com to learn more.

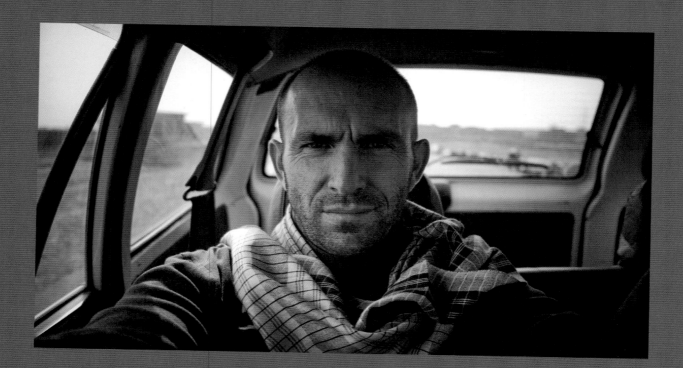

LIBERO DI ZINNO

Art Center College of Design professor and Los Angeles-based photographer/documentary filmmaker, Libero Antonio Di Zinno, was introduced to the world of working with non-profit foundations through co-teaching a prototypical ACCD class based upon the UN's MDG's (Millennium Development Goals). Subsequently, the instructors of this class were invited to be part of the team to share the best of their students' work in New York City at the United Nations' 5th annual NGO conference. Orientation as a concerned photographer included meeting and working with the founding member photographers of the illustrious VII agency when they visited Libero's alma mater in both 2006 and again in 2007, providing further tuition to his own personal body of work in the arena of aftermath or conflict zone work. Since early 2008, Libero has been an advisory board member at large for Mountain2Mountain, contributing his own images from Tibet, Nepal, and Afghanistan to M2M's group photo exhibits such as, the Views of the Himalaya (2008), Views of Afghanistan (2009), Dreams of Kabul (2010), and the most recent Streets of Afghanistan (2011-2012). Book projects include *Ultramarathon Man* by Dean Karnazes, *Surviving the Toughest Race on Earth* by Martin Dugard, and *For the Love of the Game* by Michael Jordan. His work has also been featured in *Outside* magazine, *Men's Journal,* and *ESPN* magazine. For further examples of Libero's motion or stills art, go to www.dizinno.co.uk.

Mountain2Mountain was founded in November 2006 by Shannon Galpin. For the past five years, their work has been focused in Afghanistan. Through the belief in connecting communities and cultures and the power of voice, M2M has launched projects across Afghanistan to create opportunities that were unimaginable ten years ago in education, art, sports, and activism. M2M works beyond sticks-and-bricks style projects to work in unique ways to inspire, challenge stereotypes, and combat apathy. In 2013, M2M launched its first domestic program, Strength in Numbers, in the United States to target young women who have survived gender violence here at home, while continuing to work with women and girls in Afghanistan for years to come. A portion of the proceeds from the sale of this book goes to support Mountain2Mountain.

Learn more and follow the journey at www.mountain2mountain.org.